# HOW TO DRAW
## Step by Step
### A Visual Guide to Realistic Drawing

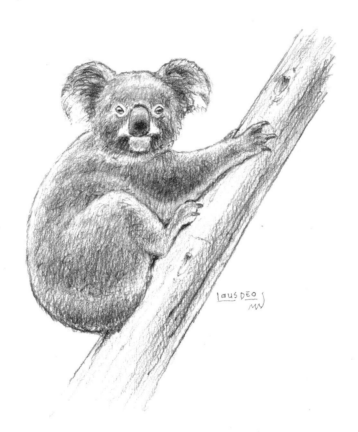

**Get Creative 6**
An imprint of Mixed Media Resources, LLC
19 W 21st St, Suite 601, New York, NY 10010

Editor
GLENI BARTELS

Associate Publisher
GLENI BARTELS

Creative Director
IRENE LEDWITH

Art Director
JENNIFER MARKSON

Chief Executive Officer
CAROLINE KILMER

President
ART JOINNIDES

Chairman
JAY STEIN

Library of Congress Cataloging-in-Publication Data has been applied for.

Manufactured in China

1 3 5 7 9 10 8 6 4 2

First Edition

Title Page:
Koala
Graphite pencil on drawing paper
6" x 6" (15cm x 15cm)

Opposite Page:
Pipes
graphite on drawing paper
5" x 6" (13cm x 15cm)

# HOW TO DRAW
## Step by Step
### A Visual Guide to Realistic Drawing

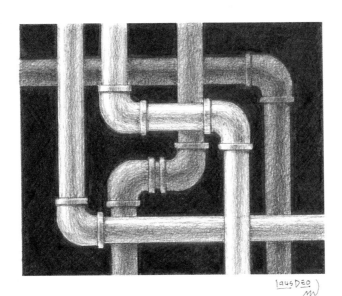

## Mark and Mary Willenbrink

# Contents

**Introduction** .......................... 5
  Two-Stage Process ..................... 5

Chapter 1: **How to Draw** ............... 6
  **Supplies and How to Use Them** ........... 7
    Pencils and Pen • Paper •
    Additional Supplies • Optional
    Supplies
  **Drawing Concepts** ...................... 10
    Structural Sketch • Values
  **Creating a Structural Sketch** ............ 12
    Measure, Proportion, and Align •
    Creating Depth with Structure
  **Adding Values** ......................... 16
    Direction of Light • Contrasting Values •
    Positive and Negative Forms •
    Creating Depth with Values •
    Creating Line Strokes

Chapter 2: **Step by Step** ............. 20
  **Using the Icons** ....................... 21
    Drawing Tools Icons • Direction of
    Light Icons • Composition Scenes Icons
  **Objects and Items** ..................... 22
    Drum • Baseball Glove • Flames •
    Gift Box • Watch • Pipes • Couch •
    Chest • Ukelele • Yo-Yo • Key •
    Candle • Candle with Flame •
    Pumpkin • Mug • Planter • Shoes
  **Food** ................................. 38
    Apple • Bread • Corn • Donut •
    Ice-Cream Cone • Grapes

**Nature** ............................... 44
  Cactus • Mountains • Flower •
  Quartz • Rocks • Tree Trunk
**Animals** ............................. 50
  Duck • Iguana • Elephant •
  Raven • Jellyfish • Horse • Koala •
  Octopus • Owl • Dog's Nose •
  Dragon • Sea Turtle • Viper
**People** ............................... 68
  Eye • Mouth • Hand • Ear • Face •
  Knight • Pirate • X-Ray
**Buildings and Places** ................. 80
  Arch • Eiffel Tower • Barn •
  Lighthouse • Hollywood Sign •
  Castle • Main Street • Mine Shaft
**Transportation** ....................... 90
  Hot Air Balloon • Airplane • Truck •
  Zepplin • Van • Boat

Chapter 3: **Put It Together** ......... 99
  **Cove Scene** .......................... 100
  **Interior Scene** ....................... 106
  **Still Life Composition** ................ 112
  **Desert Scene** ........................ 116
  **Castle Scene** ........................ 122
  **Farm Scene** .......................... 130

**The Next Step** ...................... 138
  **Glossary** ............................ 139
  **Index** .............................. 141
  **Dedication & Acknowledgments** ....... 143

# Introduction

It's amazing what can be done by applying graphite to a blank sheet of paper. Capture a moment, evoke emotions, and create images that leap off the page. *How to Draw Step by Step* is a visual guide to achieving realistic drawings.

## Two-Stage Process

The drawing process for this book uses two stages. Stage one is sketching the structural sketch. The second stage is adding values to create a drawing.

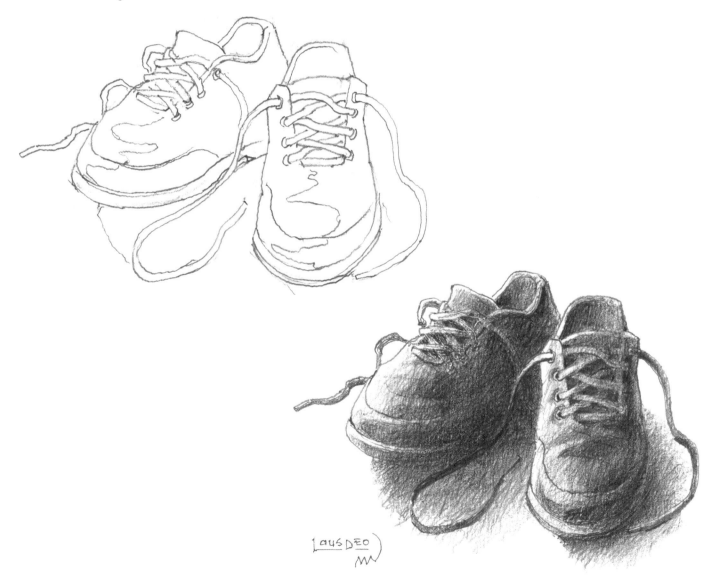

# How to Draw

Gain an understanding of how to use the supplies and learn concepts and techniques for drawing.

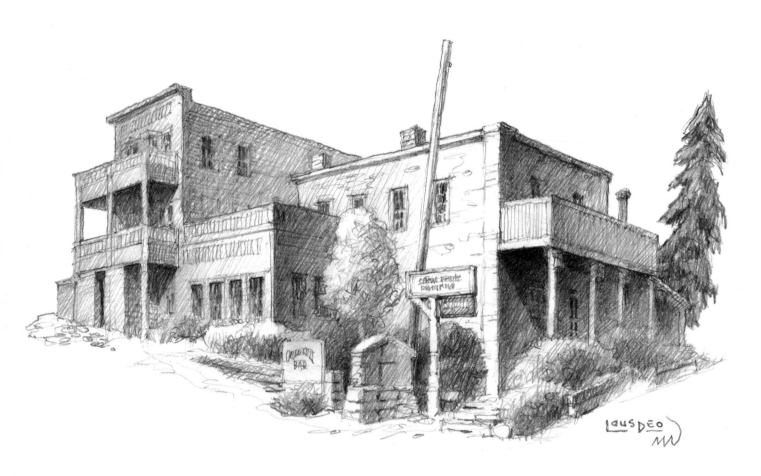

Gold Hill
Mechanical pencil on drawing paper
5" x 9" (13cm x 23cm)

# Supplies and How to Use Them

Read through the explanations for the tools in the next few pages before shopping for supplies. The icons shown beside the pencils and pen are further discussed on page 21.

## Pencils and Pens

This book uses graphite pencils, a mechanical pencil, and a ballpoint pen. Each tool has different characteristics and gives a different look to the art.

### Graphite Pencils

The core—or lead—of graphite pencils is made of graphite. The letters and numbers stamped on them refer to the hardness of the lead. Harder lead is labeled "H" and softer lead is labeled "B."

The numbers on these pencils further designate the characteristics of the lead. For H pencils, the higher the number, the greater their hardness. For B pencils, the higher the number, the softer the lead.

### Mechanical Pencils

Especially helpful for detailed drawing, mechanical pencils offer consistent, narrow line strokes. This book recommends using a mechanical pencil with 0.5 HB graphite lead, which falls between the H and the B graphite pencil leads in hardness. Mechanical pencil lead tends to break if extended too far or too much pressure is applied.

┌─────────────────────────────────┐
## WHAT YOU'LL NEED

You'll need pencils, pens, paper, and other supplies to complete the demonstrations. Here is a quick list for reference, but the materials are explained in more detail on the following pages.

### Drawing Tools

- 2B graphite pencil
- 8B graphite pencil
- Mechanical pencil with 0.5mm HB graphite lead
- Ballpoint pen with black ink

### Paper

- 5.5" x 8.5" (14 x 22cm) fine tooth (vellum) surface 98 lb drawing pad
- 9" x 12" (23 x 30cm) fine-tooth (vellum) surface 117lb drawing pad

### Additional Supplies

- Pencil sharpener
- Kneaded eraser
- Vinyl eraser

### Optional Supplies

- Eraser holders
- Ruler
- French curve
- Drawing board
- Masking tape
- Pencil extender

### Ballpoint Pens

The lines created with a ballpoint pen may range from thin and wispy to bold and dark, depending on how it is used.

# Paper

Papers differ in weight, surface texture, and their content. The weight of the paper describes its thickness. Lightweight papers, which are 50 to 70lbs, are more prone to wrinkling from line strokes and erasing than heavyweight papers of 90lbs or more. For this reason, heavyweight paper is used as the sketchbook and drawing paper in this book.

The surface texture of paper, referred to as the "tooth," varies in its smoothness or coarseness.

Smooth papers, which may be described as fine surface or vellum, are necessary for creating detailed drawings with graphite pencils or pens. Rough papers are more suitable for softer mediums such as charcoal and pastels.

The content of paper can affect its appearance over time. Acid-free paper is recommended here because it is less apt to yellow as it ages.

## Sketch and Drawing Pads

Available in different sizes, sketch and drawing pads are convenient for use at home or when out and about.

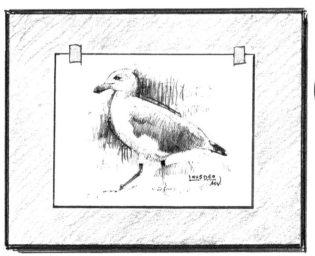

## Drawing Board and Masking Tape

Using individual sheets of paper attached to a drawing board with masking tape or clips creates a big, sturdy drawing surface.

# Additional Supplies

A pencil sharpener and erasers are also needed along with the pencils, pens, and paper.

## Pencil Sharpener

A small, handheld pencil sharpener is easy to use and is also convenient for travel.

## Kneaded Eraser

A soft kneaded eraser is less likely to damage the paper surface than other erasers and leaves no crumbs or smudges. To use, press and lift or gently rub the kneaded eraser over the paper to remove unwanted lines or shading.

## Vinyl Eraser

Hard-to-lift pencil lines can be removed using this type of plastic eraser, which is less abrasive than other erasers, and it's less likely to roughen or tear the paper surface.

# Optional Supplies

While these supplies are not necessary, they are helpful for an optimal drawing experience.

## Eraser Holders

Eraser holders allow for more precise erasing. They are refillable and available in different sizes.

## Ruler and French Curve

These tools are useful for measuring and drawing straight lines and curved lines.

## Pencil Extender

This is a sleeve that fits over the end of a shortened pencil to extend its use.

# Drawing Concepts

This section of the book holds the secrets that successful artists use every day. Actively working through these key art concepts increases confidence, thus unlocking creativity.

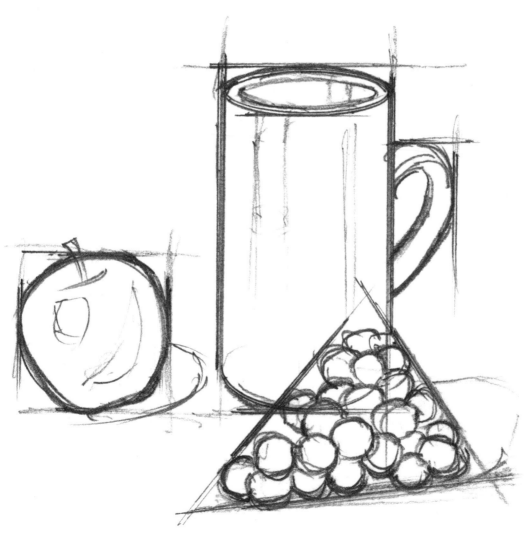

## Structural Sketch

A structural sketch is a sketch of the structural form, absent of values.

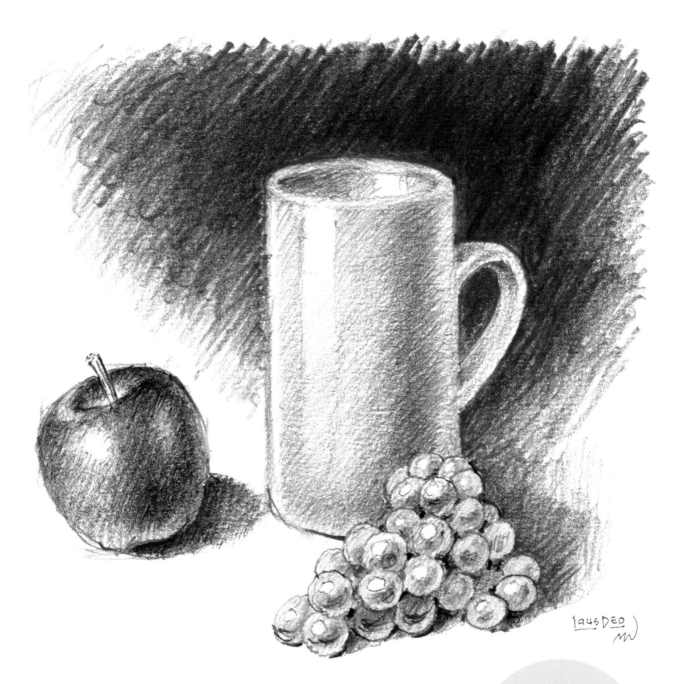

## Values

Values are the lights and darks that are added to a structural sketch to transform it into a completed drawing.

**SKETCH OR DRAWING?**

A "sketch" is a quick representation or study of a subject, whereas a "drawing" is a finished piece of art.

# Creating a Structural Sketch

This section explores techniques of sketching and drawing, such as proportioning and implying depth through perspective.

## How to Create a Structural Sketch

When drawing a structural sketch, start by looking for any circles, squares, rectangles, and triangles in the subject. Then sketch them in their proper places on the paper. As the basic shapes are placed, measure, proportion, and make alignment adjustments.

### Look for Basic Shapes

A structural sketch begins by looking for and sketching the biggest basic shapes in a composition. For example, this structural sketch begins with a circle, rectangle, and triangle. It then progresses to smaller, more detailed shapes and lines.

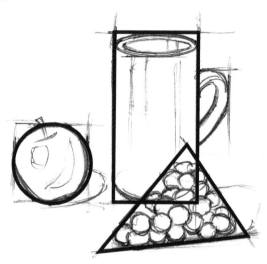

## Measure, Proportion, and Align

For a drawing to have the correct size and placement of its basic shapes, it is essential to measure, proportion, and align the elements of the structural sketch throughout the drawing process.

### Measuring

Measuring compares one element of a structural sketch to another. For this sketch, the width of the mug is measured as the distance between the pencil tip and the thumb. This distance can then be used as a gauge for comparison with other elements. To do this yourself, hold the pencil in your line of sight so that the pencil tip is at one end and your thumb is at the other end. Adjust your thumb with the tip of the pencil until its measurement is the same as the width of the mug. Continue to use this method of measurement as a way to measure the elements of the mug.

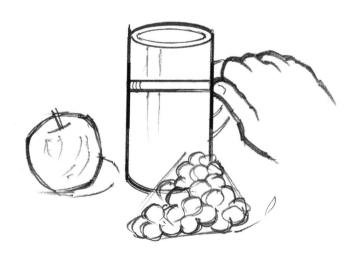

## Proportioning

Proportioning uses the measurement of one element to determine the measurement of other elements. Here, the width of the mug is used to determine the height of the mug. The measurement of the width of the mug determines that the height is equal to two of the measurements of its width.

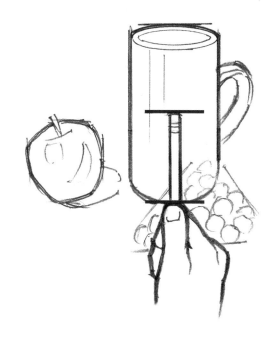

## Aligning

Aligning compares the placement of the elements of a drawing to one another vertically, horizontally, and with the subject's angles.

For example, hold a pencil or pen straight up and down, and observe what elements align vertically. Check to see that they are straight up and down. Now hold a pencil or pen straight across, and observe what elements align horizontally. Check to see that they are level with one another. When aligning angles, hold your pencil or pen at different angles to observe the relationships of the angles to the elements.

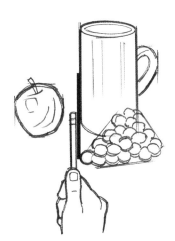

**VERTICAL ALIGNING**

*The side of the mug aligns with the grapes.*

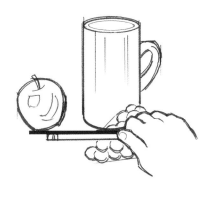

**HORIZONTAL ALIGNING**

*The bottom of the apple aligns with the bottom of the mug.*

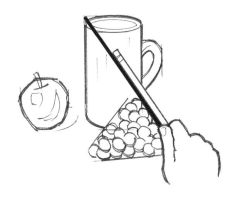

**ANGLE ALIGNING**

*The angle of the grapes aligns with the top left of the mug.*

# Creating Depth with Structure

One of the joys of drawing is creating the illusion of depth on a flat sheet of paper. This can be done by applying the principles of linear perspective.

## Linear Perspective

Linear perspective suggests depth by using size and placement of the structural elements. The horizon—where the land or water meets the sky—and vanishing points—where parallel lines appear to meet—may be used to create perspective. With linear perspective, similar elements appear closer when drawn larger, whereas distant elements appear smaller.

## One-Point Perspective

The parallel lines of railroad tracks would never meet, however a vanishing point is used to show those lines coming together at the horizon to create perspective. This scene has only one vanishing point, making it a one-point-perspective drawing.

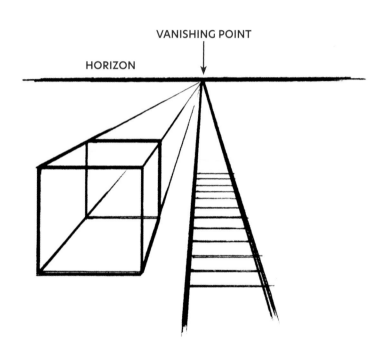

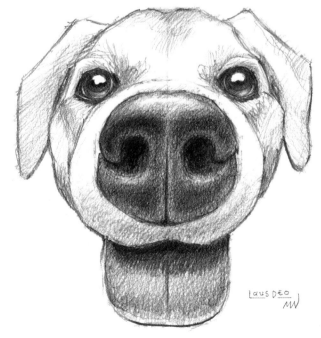

**PERSPECTIVE IN YOUR FACE**

*Because its nose is purposefully drawn large compared to the rest of its face, this dog looks like it's coming up to say "Hi!" This is an example of perspective.*

## Two-Point Perspective

Two-point perspective is similar to one-point perspective, except it uses an added vanishing point.

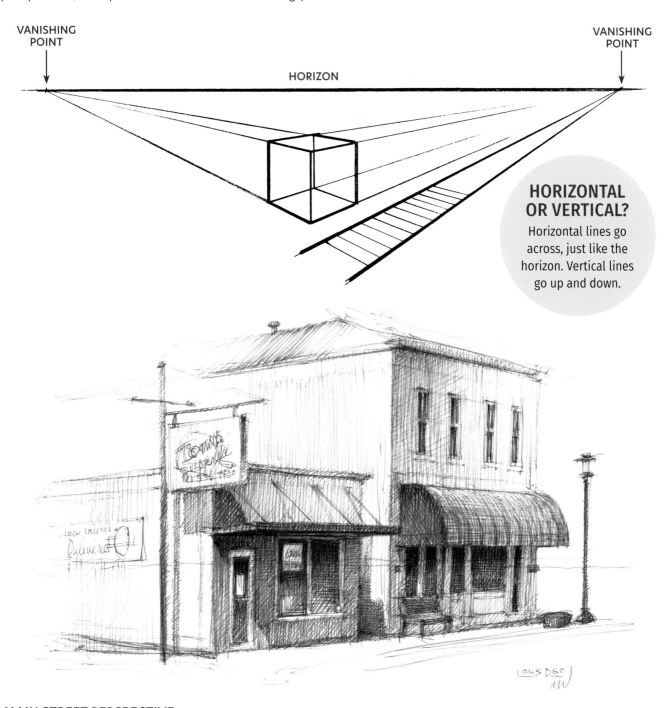

VANISHING POINT

VANISHING POINT

HORIZON

### HORIZONTAL OR VERTICAL?
Horizontal lines go across, just like the horizon. Vertical lines go up and down.

### MAIN STREET PERSPECTIVE

*The boxlike forms of these two buildings are an example of two-point perspective. Though the vanishing points don't appear in the drawing, the lines of this Main Street scene slope toward vanishing points that are beyond the page.*

# Adding Values

Values are the lights and darks of a drawing. Values not only add depth, they may also be used to set the mood or add a sense of realism.

## Direction of the Light

The direction of the light source affects the placement of the values—the lights, darks, and shadows—in a drawing. A direction of light icon is included and is further discussed on page 21.

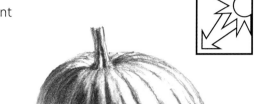

DIRECTION
OF LIGHT

**THE INFLUENCE OF LIGHT**

*In this drawing, the direction of the light source is from the upper right, which creates highlights on the upper right of the pumpkin and shadows toward the left.*

## Contrasting Values

Contrast refers to the difference in values. The values in a drawing may be of low contrast or extreme contrast or somewhere in between.

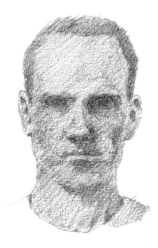

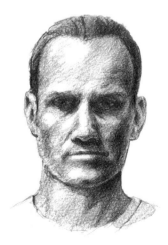

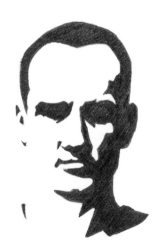

**LOW CONTRAST**

*A low contrast drawing uses similar values instead of the whole value scale. This can be used to make background elements appear distant.*

**MODERATE CONTRAST**

*Using lighter, middle, and darker values gives a drawing a natural feeling of depth.*

**EXTREME CONTRAST**

*An extreme contrast approach uses black and white with few or no middle values, giving a stark appearance to the drawing.*

# MAKING AND USING A
# VALUE SCALE

Value scales, also called gray scales, help compare the values of a subject to the drawing. You can purchase a value scale, but they are easy to make!

**1.** On a sheet of 9" x 12" (23cm x 300cm) fine-tooth (vellum) surface 117lb drawing paper, use a 2B graphite pencil to make lines that transition from the lightest to its darkest value.

**2.** Use an 8B graphite pencil to create the darkest values.

**3.** Draw a rectangle around the area, making sure to include an area that is the white of the paper. A completed value scale should graduate from the white of the paper to the darkest shading.

**4.** Trim the value scale so that it can be held to compare the scale to the values in the drawing.

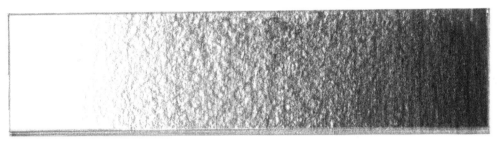

# Positive and Negative Forms

While positive forms are recognized by their own shapes, negative forms are implied by their surroundings.

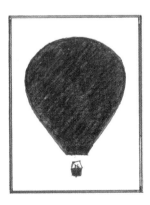

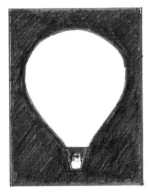

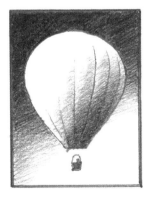

**POSITIVE FORM**
*The dark image of the hot air balloon against the light background can be thought of as a positive image.*

**NEGATIVE FORM**
*The light image of the hot air balloon against the dark background can be thought of as a negative image.*

**COMBINING POSITIVE AND NEGATIVE**
*Where the balloon is dark, and the background is light, and where the balloon is light, the background is dark.*

# Creating Depth with Values

Atmospheric perspective implies depth through the use of detail and values.

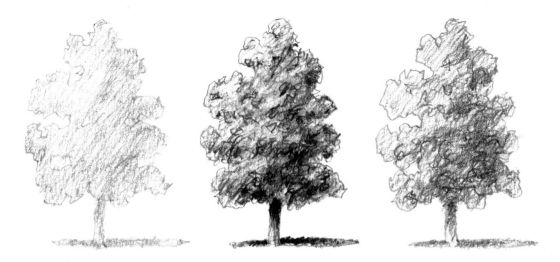

**ATMOSPHERIC PERSPECTIVE TO CREATE DEPTH**

*Though these three trees are actually the same size, the center tree is drawn with more detail and uses a wider range of values compared to the other trees, giving the impression that the middle tree is closest.*

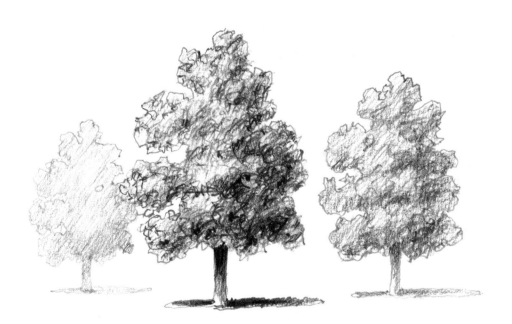

**LINEAR AND ATMOSPHERIC PERSPECTIVE TOGETHER**

*Using the same three trees, linear perspective is added to this composition with the atmospheric perspective by adjusting the sizes of the trees.*

# Creating Line Strokes

Values, which are the lights and darks of a drawing, are added by using line strokes with the pencil or pen.

## Pencil and Pen Grips

By changing the grip of a pencil or pen in relation to its angle to the paper, a variety of strokes and shading can be achieved.

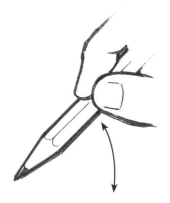

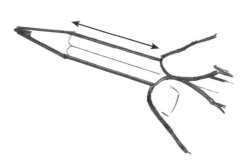

### ANGLE TO THE PAPER
*An upright angle produces thinner lines, whereas angling the pencil lead closer to the paper produces wider lines.*

### DISTANCE OF THE GRIP
*A tight grip near the end of the pencil or pen is useful for short, controlled lines, whereas a grip farther from the point may make longer, looser lines.*

## Adding Shading and Texture

A variety of line strokes may be used to add shading and texture to a drawing. Common line stroke techniques are shown below using different pencils and a pen. Have fun practicing how to grip the pencils and pen while trying these techniques.

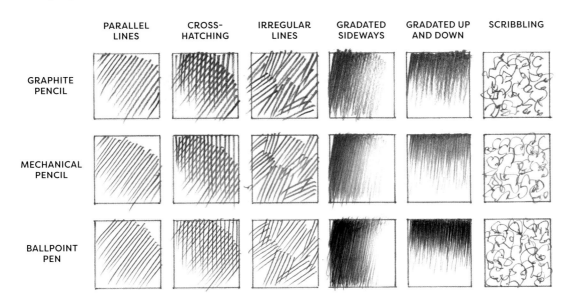

|  | PARALLEL LINES | CROSS-HATCHING | IRREGULAR LINES | GRADATED SIDEWAYS | GRADATED UP AND DOWN | SCRIBBLING |
|---|---|---|---|---|---|---|
| GRAPHITE PENCIL | | | | | | |
| MECHANICAL PENCIL | | | | | | |
| BALLPOINT PEN | | | | | | |

# Chapter 2
# Step by Step

Created as a visual guide, these demonstrations have minimal words with large visual steps.

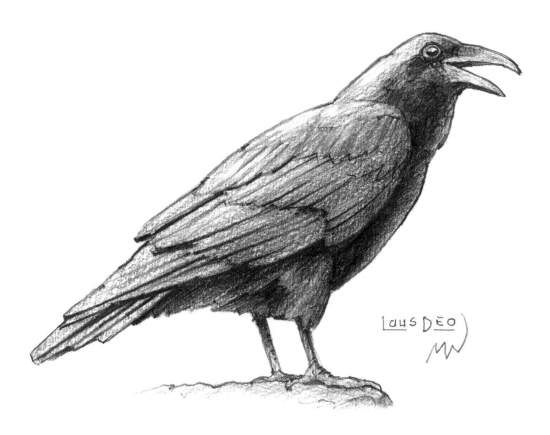

Nevermore
Graphite pencil on drawing paper
5" x 6" (13cm x 15cm)

# Using the Icons

Become familiar with the icons used in the demonstrations. Each icon visually directs which drawing tools are needed and shows the direction of the light source. Composition scenes icons are used if a subject appears in chapter 3.

## Drawing Tools Icons

These icons show which graphite pencils, mechanical pencil, or ballpoint pen are to be used to draw each demo.

| 2B GRAPHITE PENCIL | 8B GRAPHITE PENCIL | MECHANICAL PENCIL | BALLPOINT PEN |

## Direction of Light Icons

Light source in front of the subject: The direction of the primary light source is in front of the subject, which casts shadows behind it ("Apple," page 38).

Light source behind the subject: The direction of the primary light source casts the shadows to the front ("Shoes," page 37).

| FRONT LEFT | FRONT UPPER LEFT | FRONT OVERHEAD | FRONT UPPER RIGHT | FRONT RIGHT |

   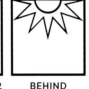 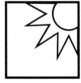 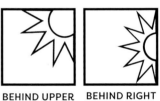

| BEHIND LEFT | BEHIND UPPER LEFT | BEHIND OVERHEAD | BEHIND UPPER RIGHT | BEHIND RIGHT |

## Composition Scenes Icons

An icon will appear at the top of the page if the subject of a demonstration is included in a composition scene in chapter 3. These scenes are:

| COVE | INTERIOR | STILL LIFE |

| DESERT | CASTLE | FARM |

# Drum

In this demonstration, there are ellipses, which are circles drawn in perspective. Ellipses have round ends even when flattened.

① _____

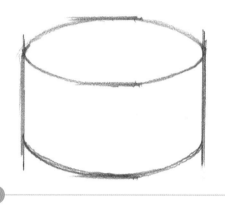

② _____

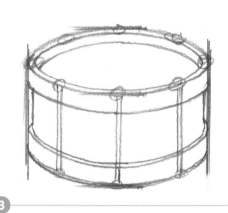

③ _____

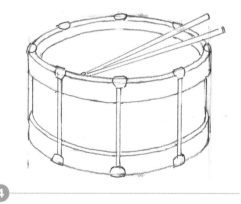

④ _____

## SIGN AND DATE YOUR DRAWINGS

By signing your artwork and writing the date on it, you will have a sense of ownership as well as the ability to chart the progress of your drawings over time.

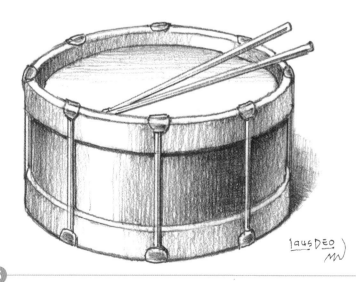

⑤ _____

22

# Baseball Glove

Start by drawing the basic shape of the palm and fingers, with a triangle for the thumb. After the form of the glove is developed, finish the drawing by adding values.

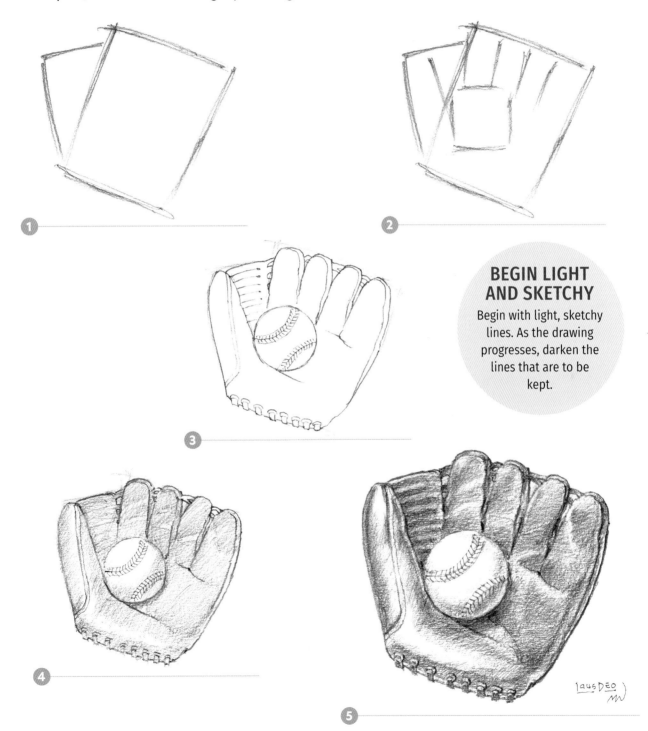

## BEGIN LIGHT AND SKETCHY

Begin with light, sketchy lines. As the drawing progresses, darken the lines that are to be kept.

# Flames

The flames are the light source in this drawing. Their brightness is enhanced by leaving the lightest areas the white of the paper and making the background dark with the 8B pencil. This creates an interesting contrast.

1

2

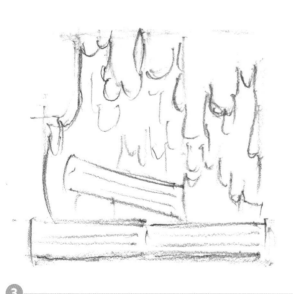

3

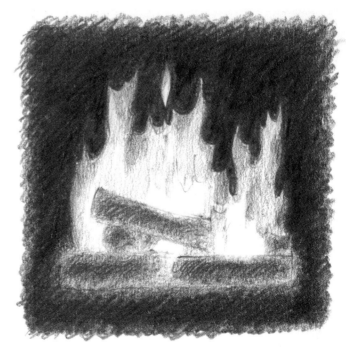

4

LAUS DEO

# Gift Box

Who doesn't love getting a present? For this drawing, start with lines for the forward corner, then add the sides and top to form the basic box shape. Consider decorating the wrapping paper with your own style.

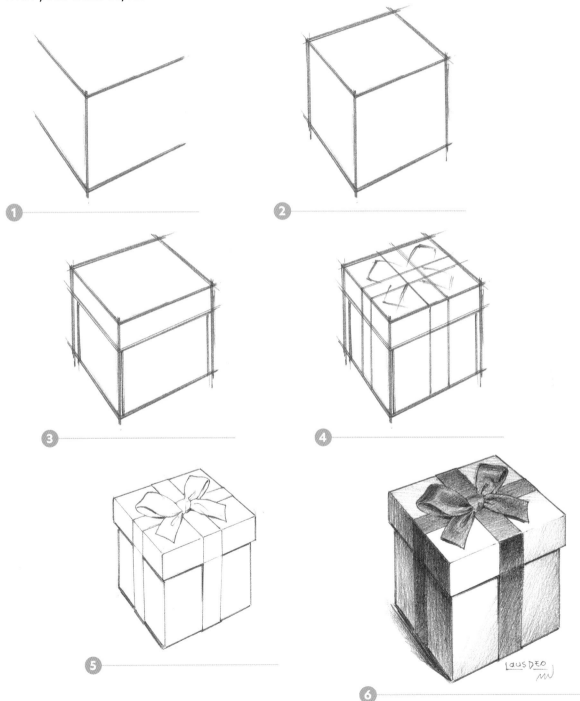

# Watch

Contrasts and subtle variations of values are used to suggest the shiny surfaces of the glass lens and metal case.

Contrasts and subtle variations of values are used to suggest the shiny surfaces of the glass lens and metal case.

1

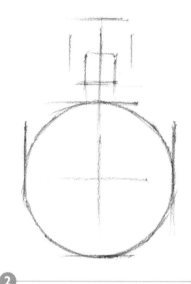

2

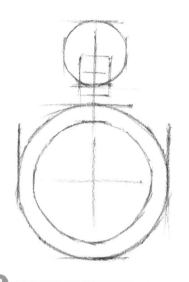

3

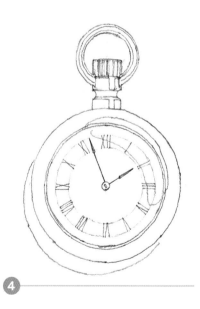

4

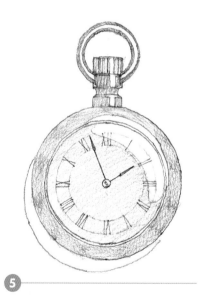

5

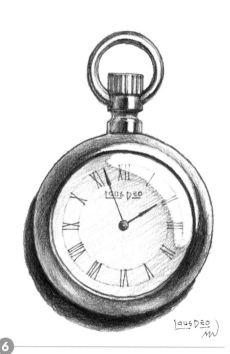

6

# Pipes

Depth is implied by the overlap of the pipes and by using values. The lightest pipes are closest, while the distant pipes are darker.

1

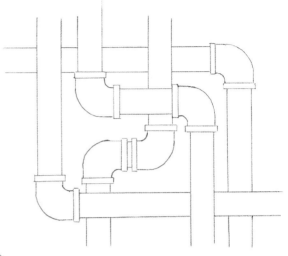

2

## THE VALUE OF VALUES

Use a value scale (see page 17) to compare and adjust the values of a drawing as it progresses to create more depth.

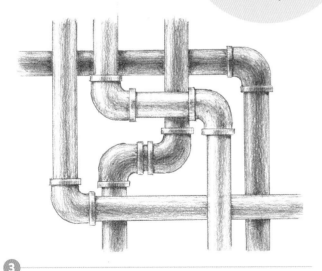

3

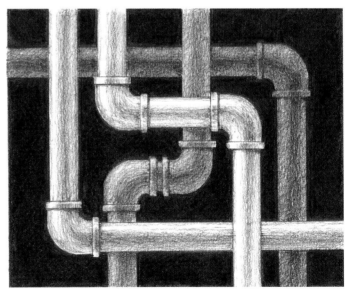

4

# Couch

This one-point-perspective drawing uses a single vanishing point. Use this vanishing point to draw lines from the 3 corners of the couch.

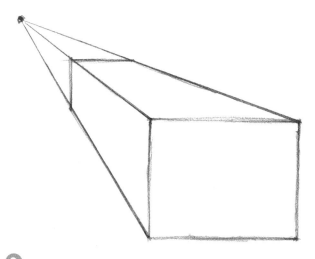

**1** **Sketch the Side of the Couch and Mark the Vanishing Point**
Sketch the forward side of the couch as a rectangle. Place a dot at the upper left for the vanishing point.

**2** **Sketch the Far End of the Couch**
Sketch lines from the three corners of the rectangle to the vanishing point. Add the vertical and horizontal lines to form the far end of the couch.

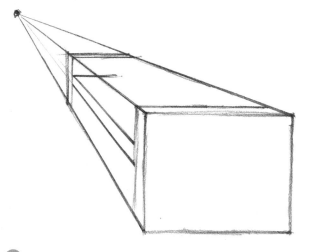

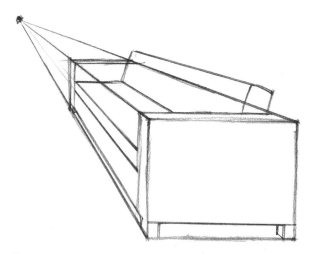

**3** **Form the Couch**
Sketch narrow box shapes at the ends of the couch, and sketch the cushions.

**4** **Add Details**
Sketch the details, including the back cushions and legs.

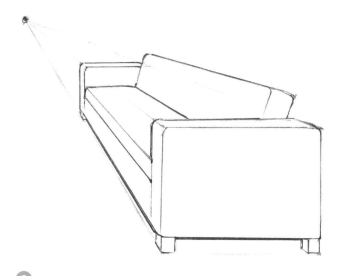

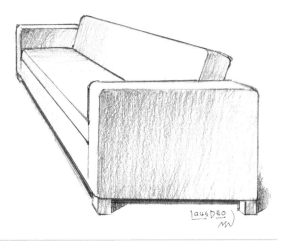

## 5 Refine the Form
Round the corners and erase unwanted lines.

## 6 Add Values
Add the light, middle, and dark values to complete the drawing.

# Chest

This drawing uses two-point perspective to give the chest an angled appearance.

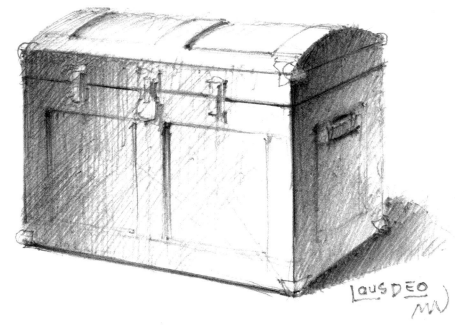

# Ukulele

A 2B graphite pencil is used for this drawing, along with a mechanical pencil in steps 4 and 5, to capture the finer details of this drawing. A straight edge is helpful for the straight lines. Note that the neck of the ukulele narrows slightly the farther it gets from the body of the instrument.

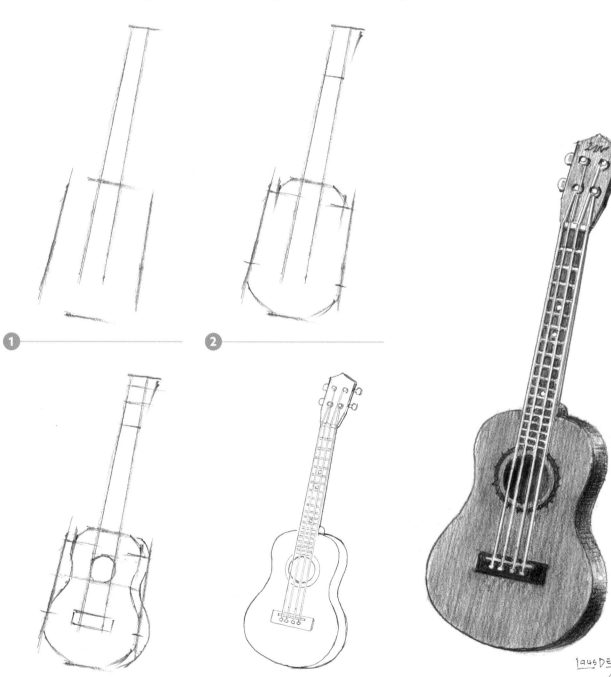

# Yo-Yo

This yo-yo is to be drawn using ellipses, which are circles in perspective. The shiny appearance comes from gradated values, along with sharp, clean edges.

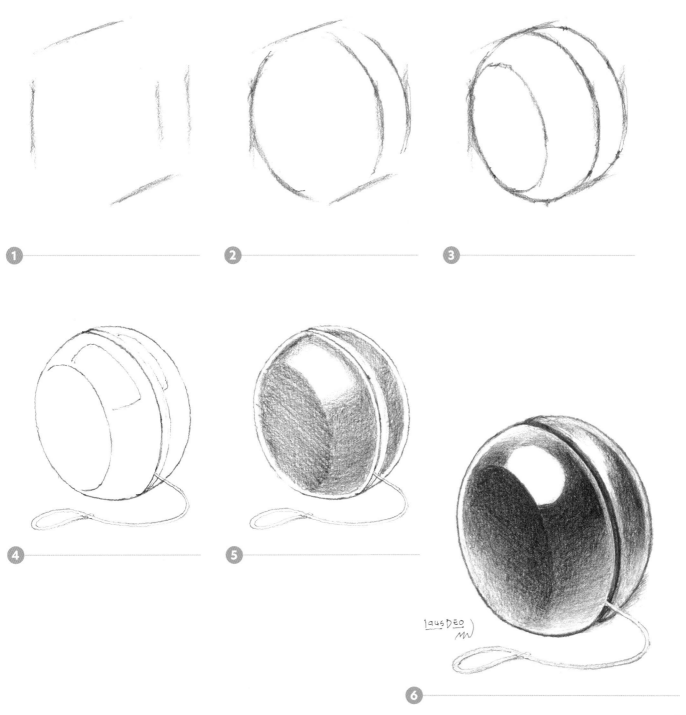

# Key

Sharply defined highlights contrasted with dark values give this key drawing its metallic appearance.

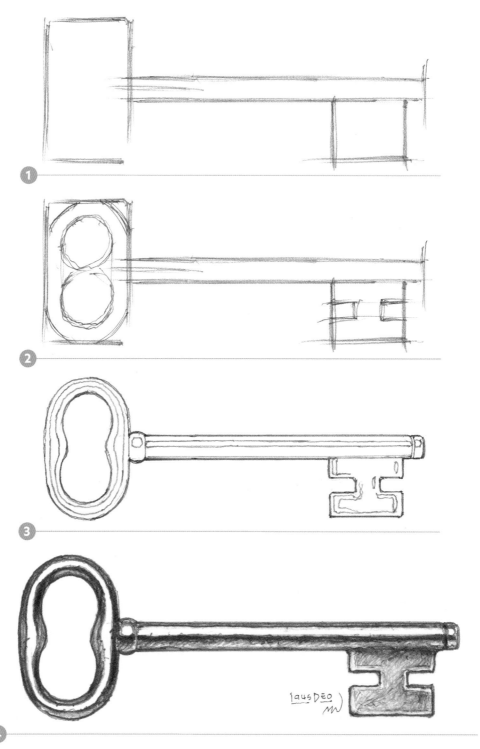

# Candle

The light source for this drawing is from the upper left, which causes the left side of the candle to be lighter than the right side.

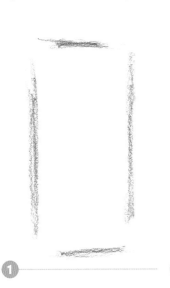

① 

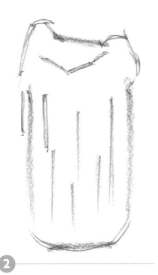

②

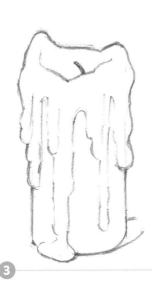

③

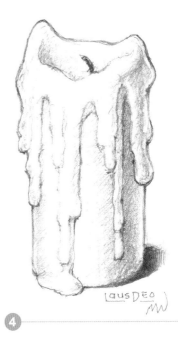

④

# Candle with Flame

By adding a dark background and having only the flame as the light source, this candle looks dramatically different from the previous drawing, even though it uses a similar structural sketch.

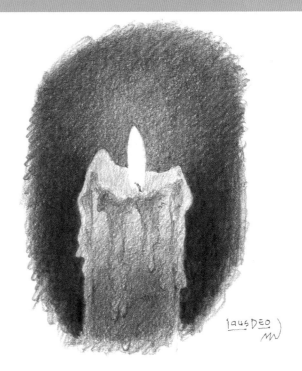

33

# Pumpkin

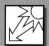

The creases of this pumpkin are sketched by starting at the center, then moving outward to the sides of the pumpkin.

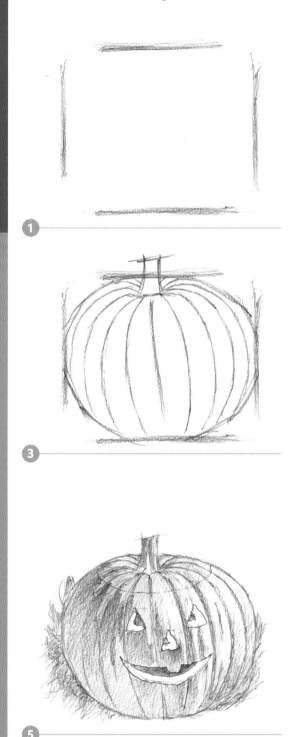

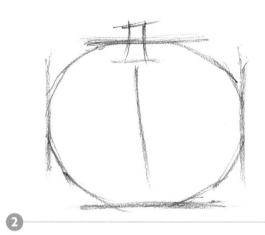

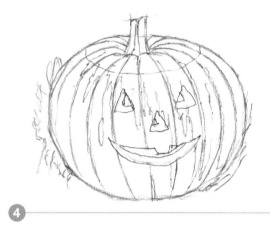

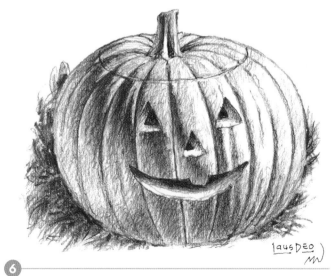

The height of this mug is twice its width. The process of measuring and proportioning this drawing is shown in detail on page 12.

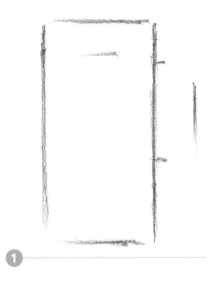

**1**

### THERE'S NO POINT

The ends of an ellipse are always rounded—not pointed—even when an ellipse is very flat.

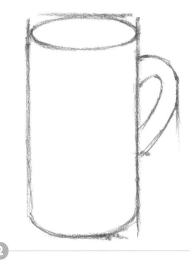

**2**

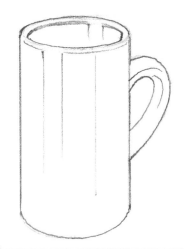

**3**

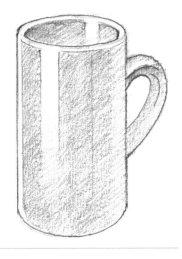

**4**

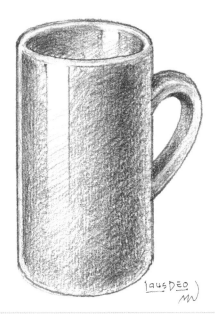

LAUSDEO

**5**

# Planter

The lighting of the shapes adds interest to this drawing. Experiment with different pencil lines to create the textures.

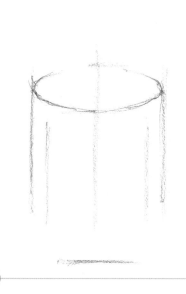

1

2

3

4

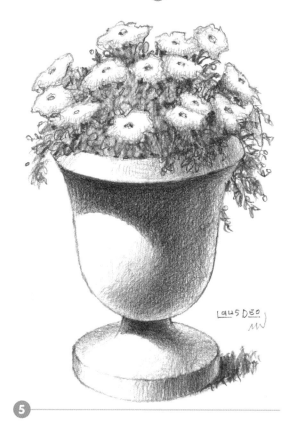

5

# Shoes

With the light source behind the shoes from the upper left, the shadows are cast forward, in front of the shoes.

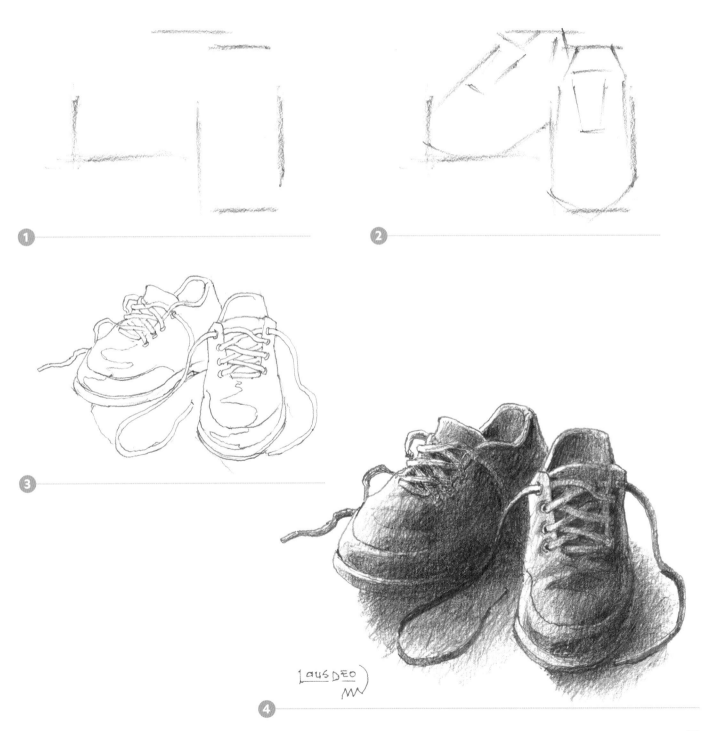

# Apple

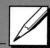  

Set up an apple for observation. With the light source in front of the apple from the upper left, the shadow is cast to the right, as shown here. Move the light source to see how it affects the highlights and shadows.

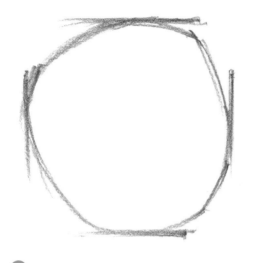

1

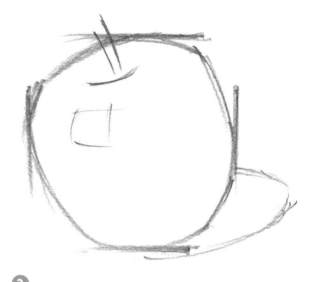

2

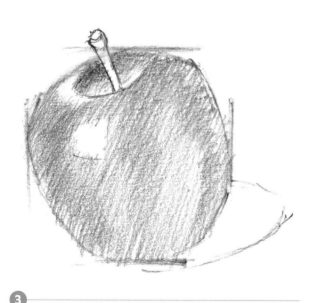

3

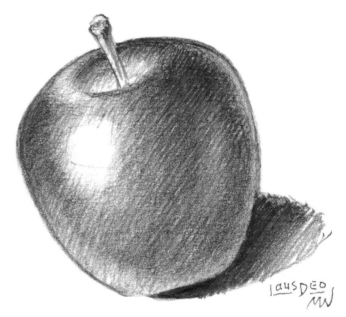

4

When adding values, the line strokes follow the contours of the bread.

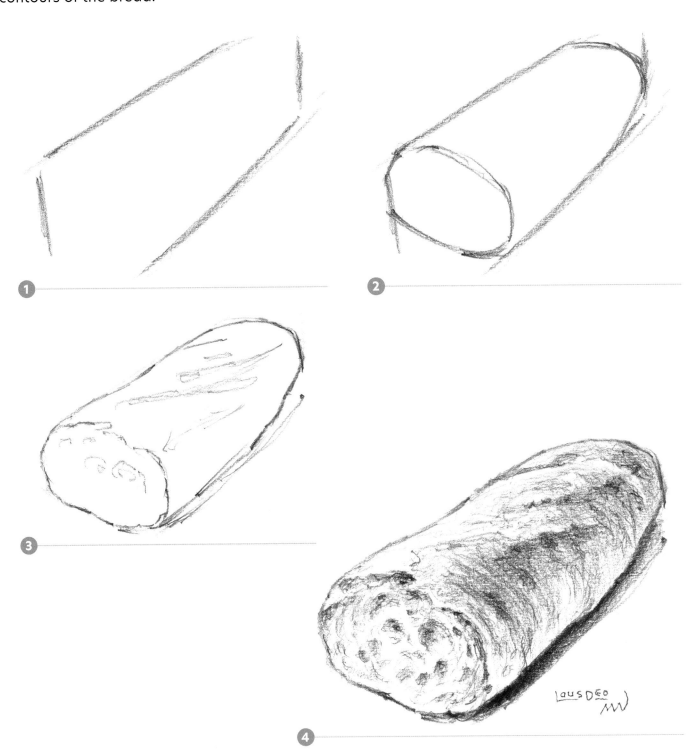

# Corn

With its patterned kernels and the ribbonlike sheaths of the husk, an ear of corn offers an interesting subject to draw. After completing these lessons, consider setting up your own still life drawings.

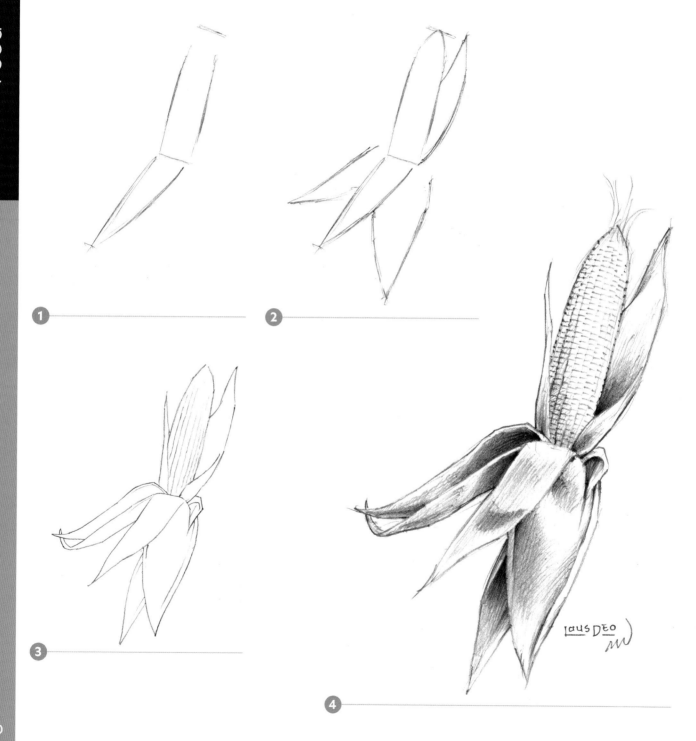

1

2

3

4

# Donut

For this demonstration, you may need two donuts—one
for observation and one to eat.

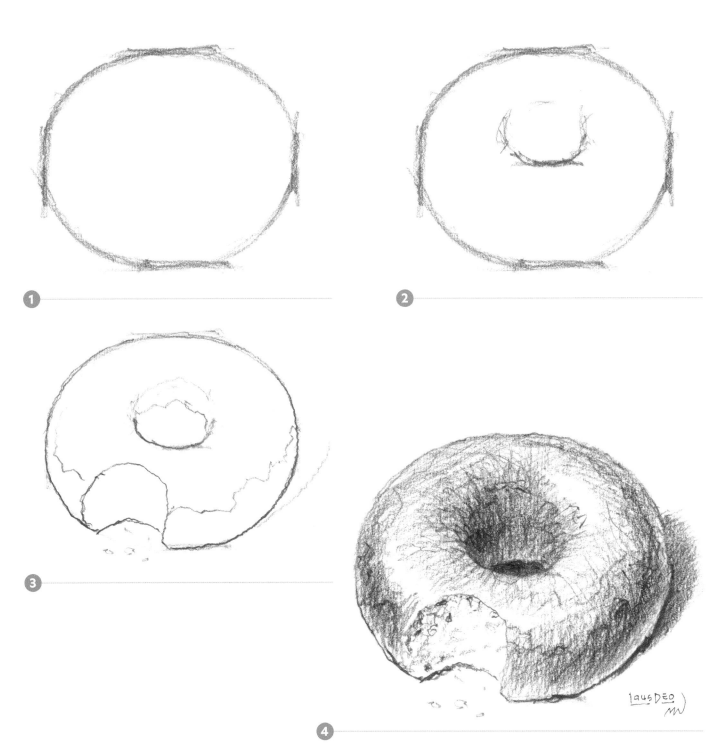

# Ice-Cream Cone

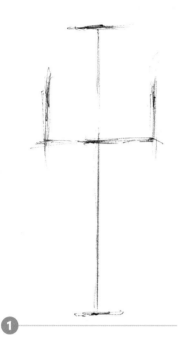Food

Sketching a vertical centerline helps to keep the ice-cream cone symmetrical. Adding more vertical lines will blend the centerline into the shading of this ballpoint pen drawing.

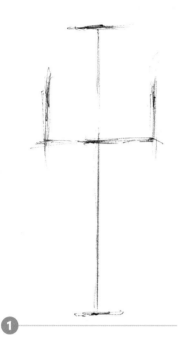

**1**

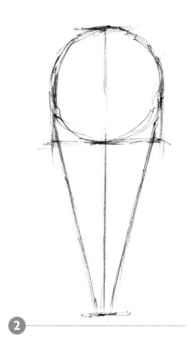

**2**

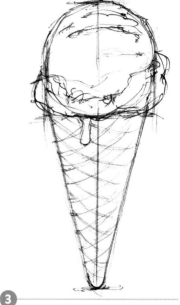

**3**

### THE BLOB!
Frequently wiping the tip of a ballpoint pen on a scrap of paper helps prevent ink blobs from occurring during the drawing process.

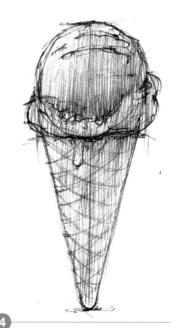

**4**

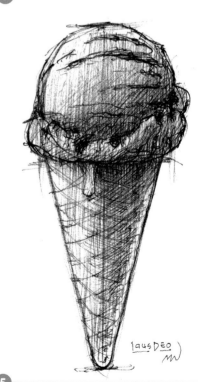

**5**

# Grapes

The grape clusters are triangular in shape. The white highlights with the darks next to them create contrasting values that add depth to the finished drawing.

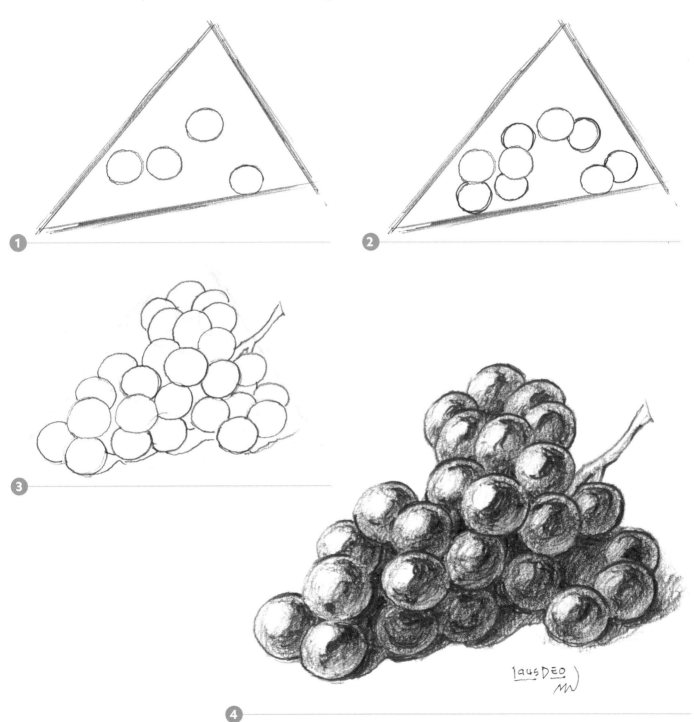

43

# Cactus

This prickly cactus and the next demonstration of the mountains are both in the Desert Scene (page 116). Both drawings share the light source from the upper right.

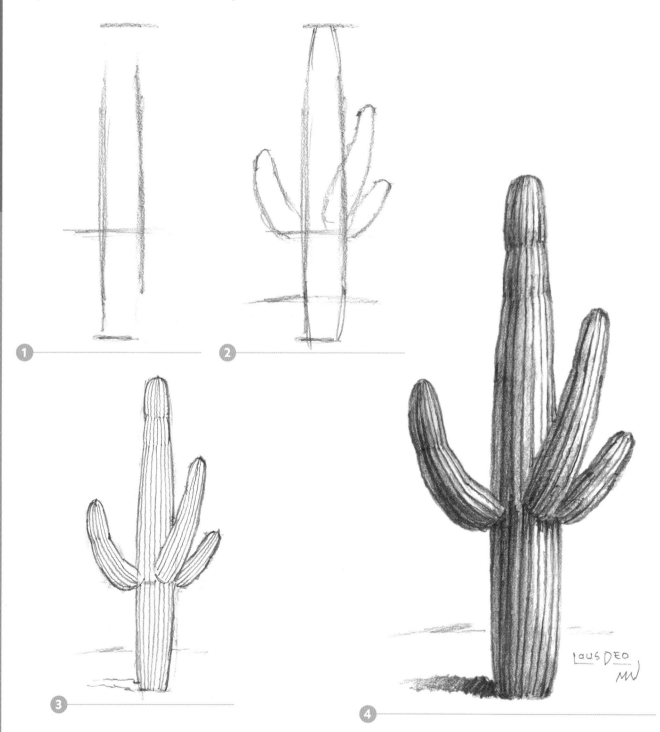

# Mountains

Horizontal lines drawn at the top and bottom are used
to proportion and place the forms of the mountains.

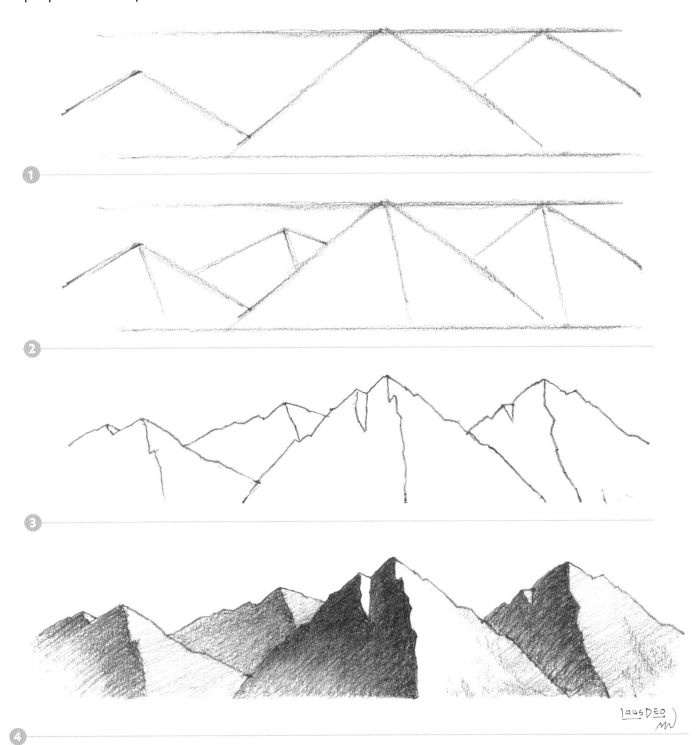

①

②

③

④

# Flower

When adding values to this flower drawing, note that the petals gradate from dark at the top to lighter toward the bottom because of the colors of the flower.

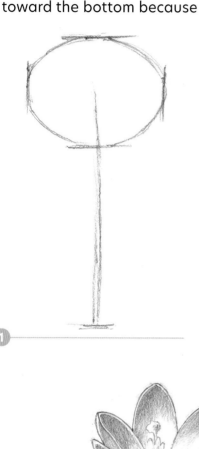

①

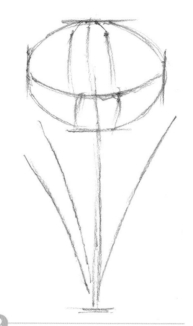

②

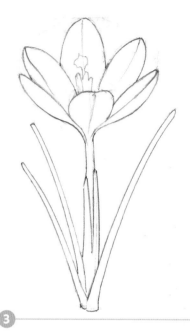

③

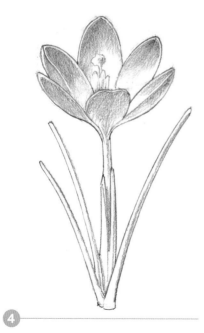

④

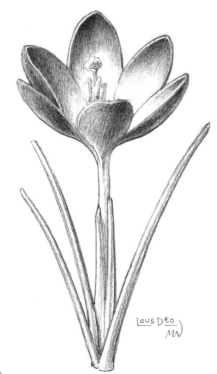

Laus Deo
MN

⑤

46

# Quartz

By making the background of this drawing dark, the translucent quality of the quartz is accentuated, which creates a dramatic effect.

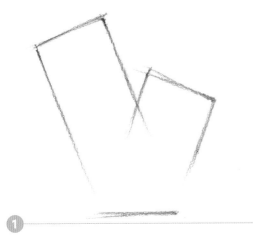

1

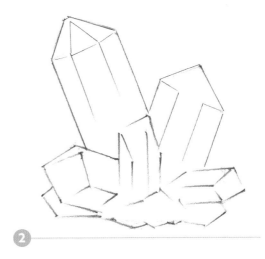

2

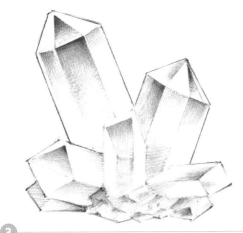

3

**SHARING YOUR ART**

Consider blessing friends and family with your drawings in the form of greeting cards and framed art.

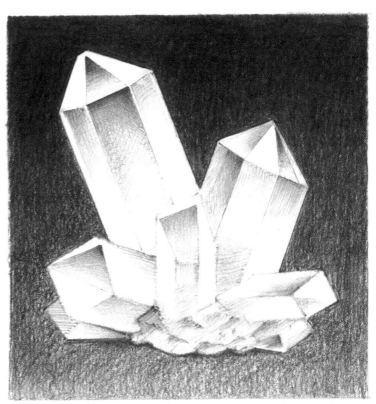

4

# Rocks

This drawing of rocks is similar to the rocks in the Cove Scene (page 100), with the light source from the front upper left.

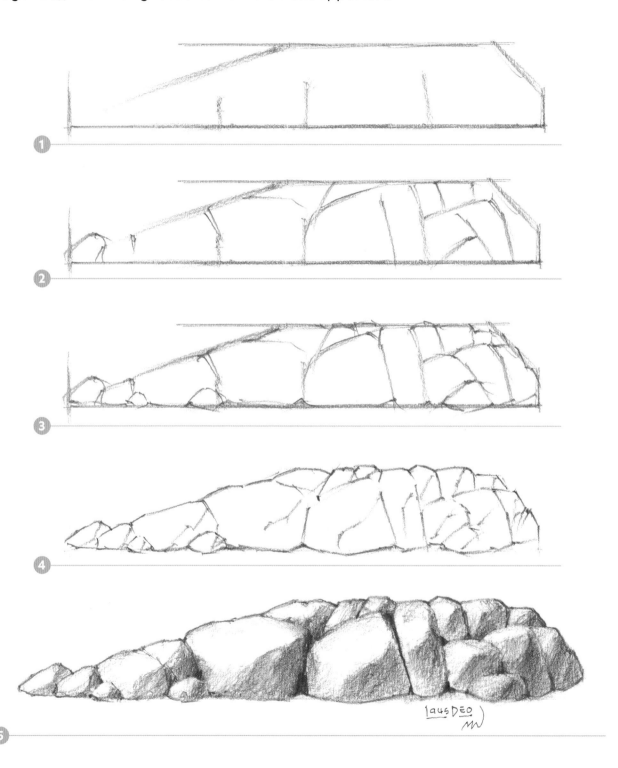

1

2

3

4

5

# Tree Trunk

Draw the coarse texture of the tree bark with directional lines that follow the knotty shape of the trunk.

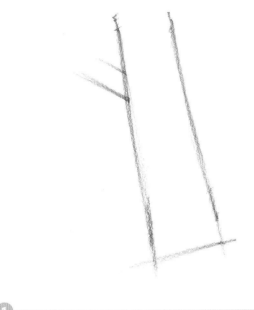

1

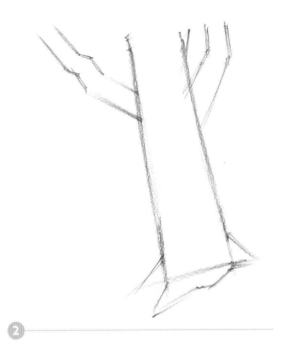

2

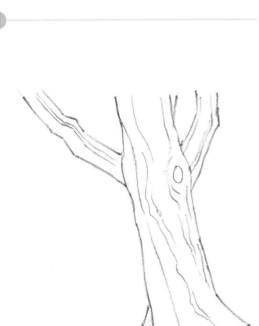

3

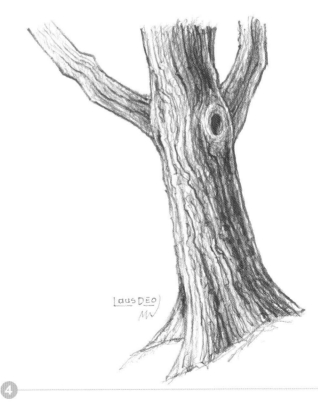

4

# Duck

Most ducks are identifiable by their distinctive markings with subtle value gradations on their midsection and strong contrasts in the tail feathers. Use the 2B graphite pencil for most of the shading, saving the darkest areas for the 8B graphite pencil.

1

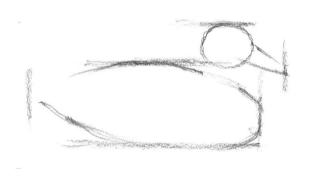

2

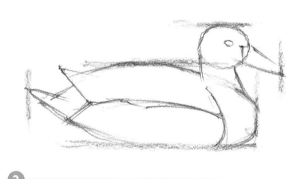

3

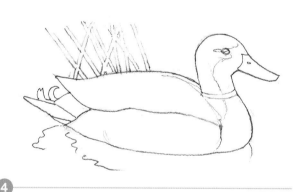

4

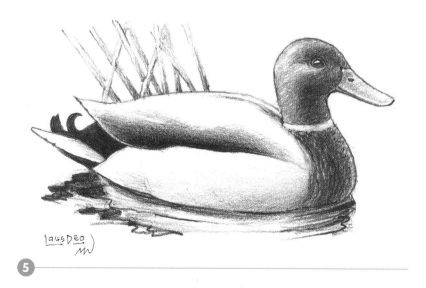

5

# Iguana

For this drawing, use the mechanical pencil to achieve the detailed patterns of the iguana's skin. Many controlled line strokes are used to create the shading.

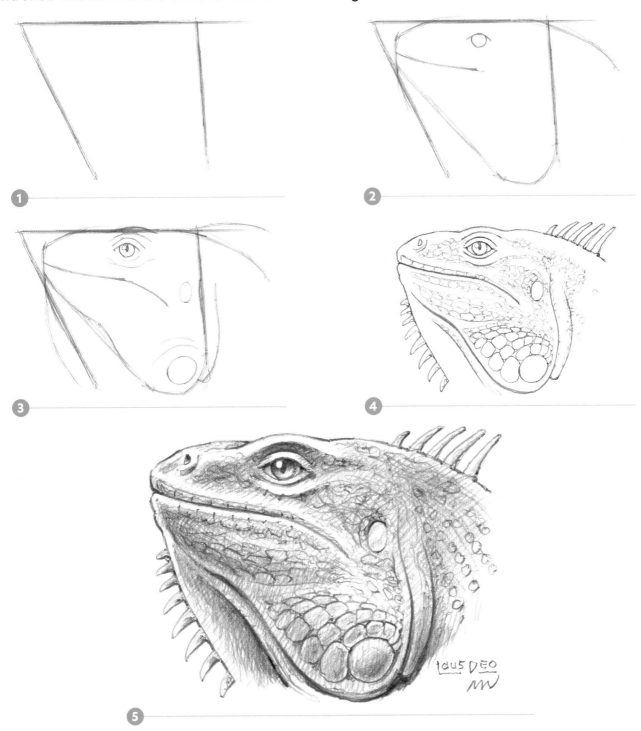

# Elephant

How do you draw an elephant? One step at a time! Proportion the outer boundaries and form the elephant. When shading (see page 19), hold the pencil so that the graphite is flat to the paper.

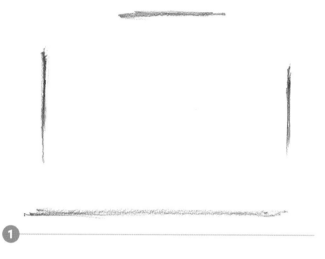

1

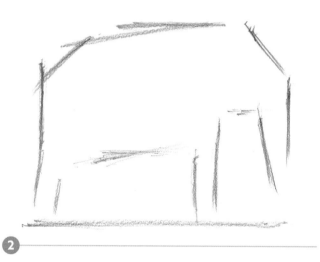

2

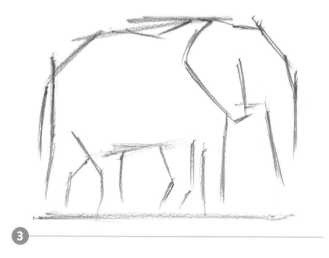

3

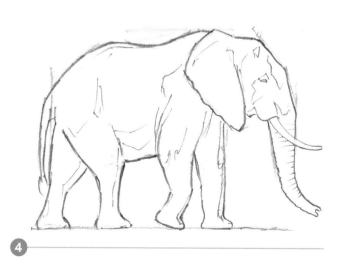

4

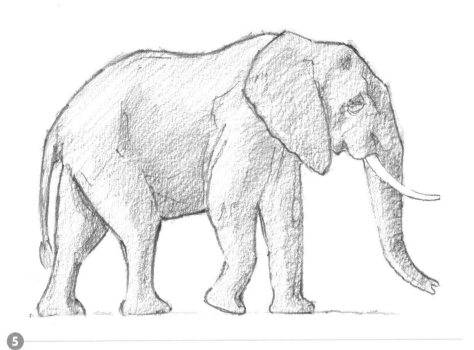

5

**PRESS
AND LIFT**
Gently press the
kneaded eraser to the
paper's surface, lifting
graphite to lighten
the drawing.

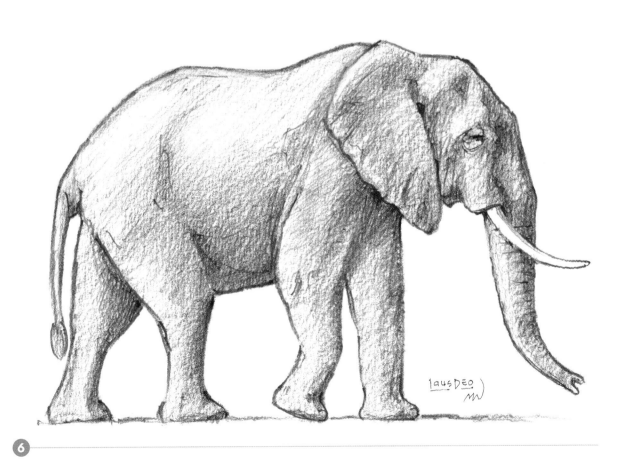

6

53

# Raven

Use the mechanical pencil to draw the detailed linework for this demonstration. With the 2B graphite pencil, apply the light and middle values of the raven. Lift graphite from the areas that are to be lightened with the kneaded eraser. Shade the darkest areas with the 8B graphite pencil.

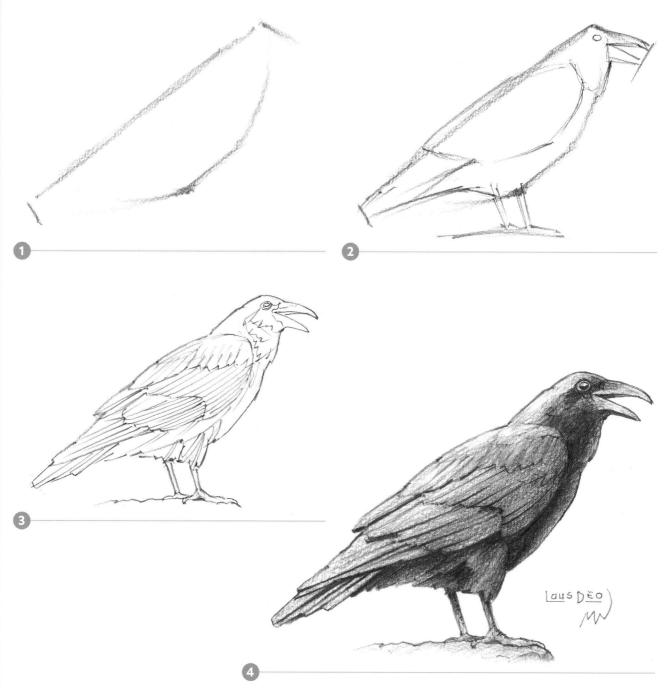

# Jellyfish

Sketch each tentacle with one line curved and the other ruffled, allowing the sides to meet and overlap to create a twist. The shading effects create the illusion of transparency.

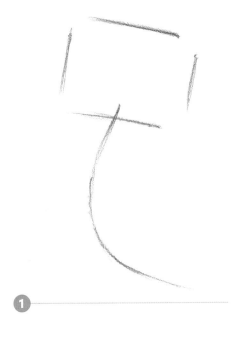

1

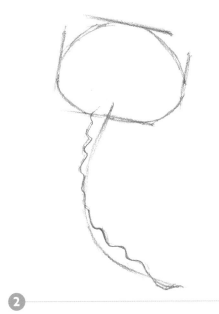

2

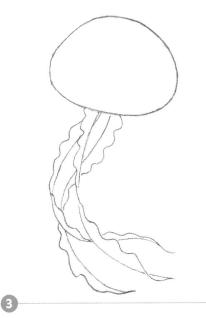

3

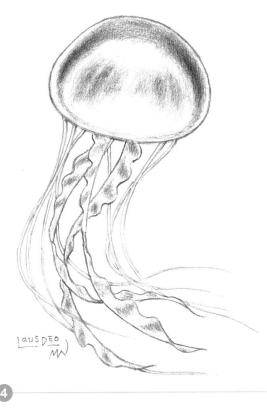

4

# Horse

When creating the muscular form of the horse, pay special attention to the subtle changes in the light and dark values.

Animals

1

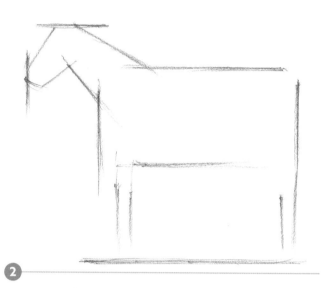

2

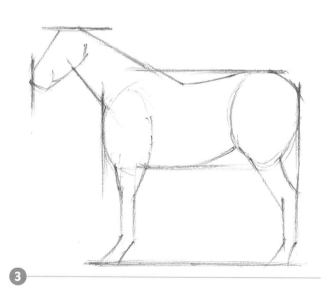

3

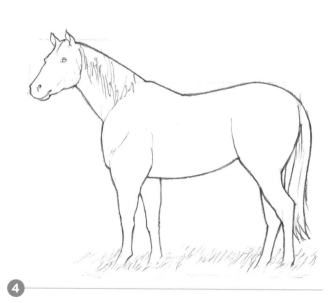

4

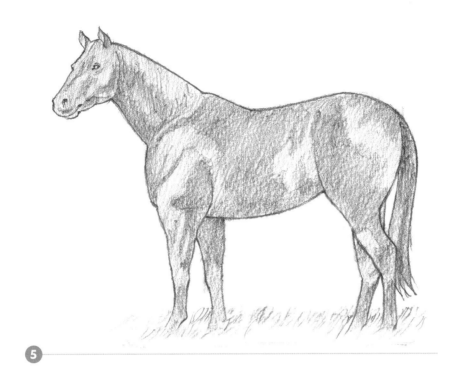

5

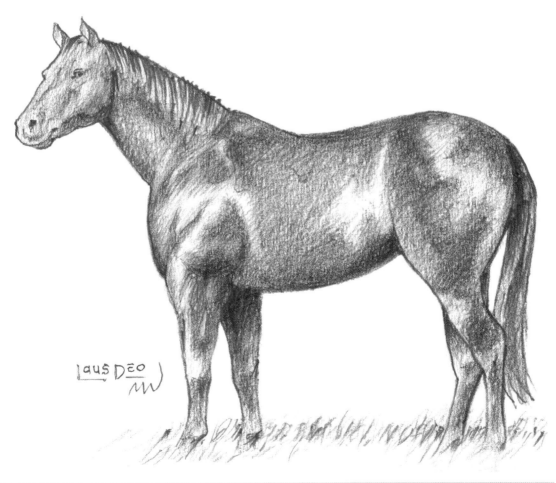

LAUS DEO

6

# Koala

Short line strokes with the side of the 2B pencil create
the soft appearance of this koala's fur.

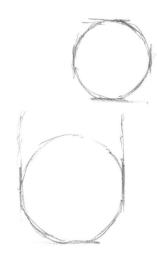

1

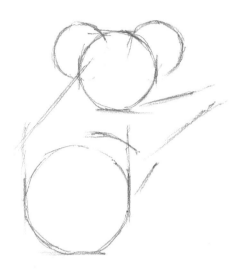

2

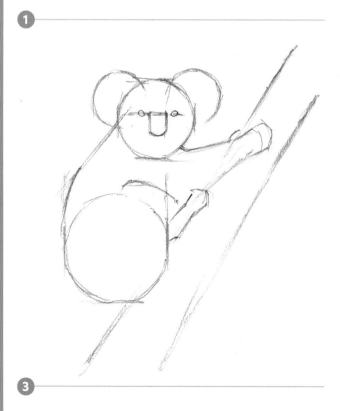

3

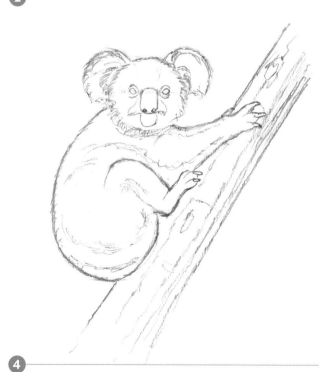

4

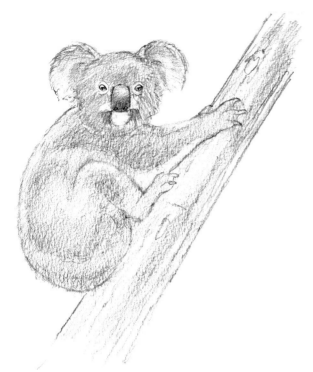

5

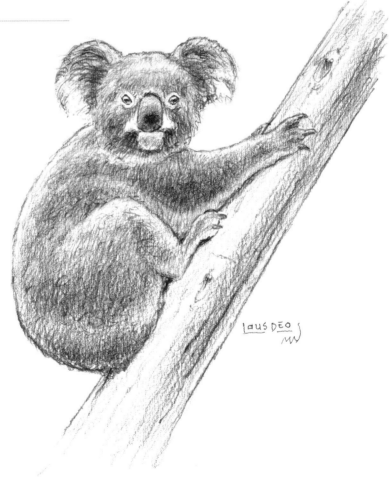

6

59

# Octopus

Using the 2B pencil, sketch the outer proportions of the form of the octopus. Adding the ovals, curved lines, and details, create the structural sketch. Add values to the drawing using the 2B pencil, along with the mechanical pencil for the final details.

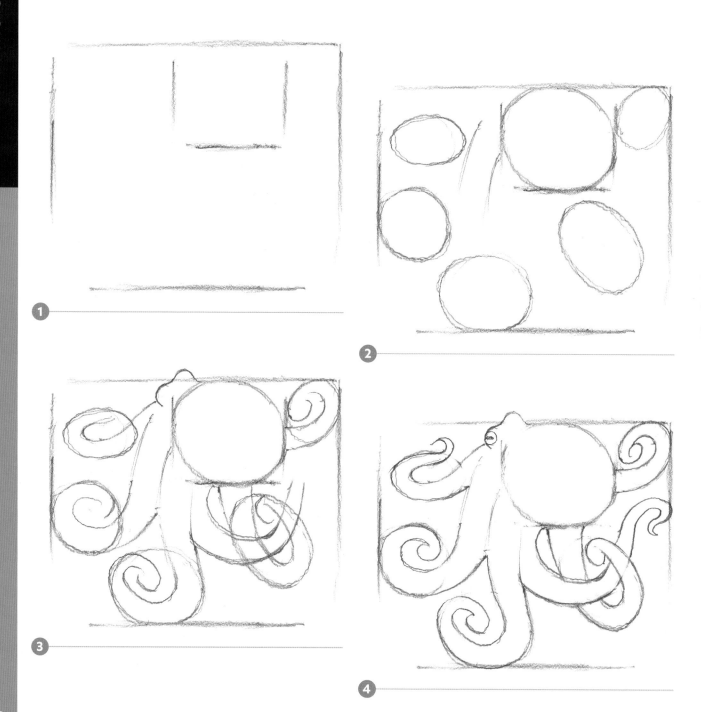

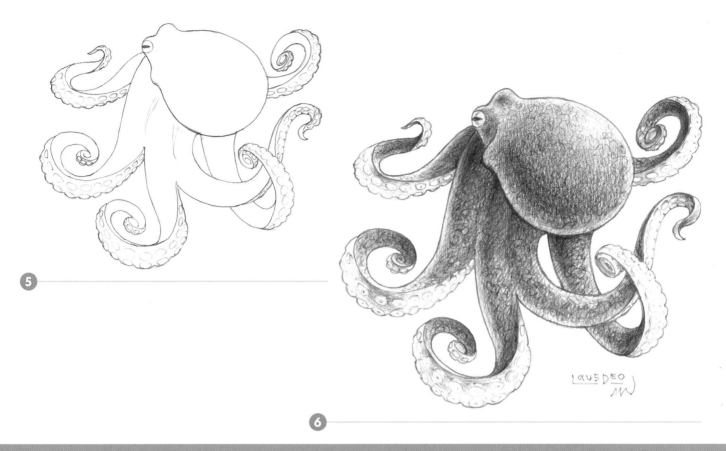

5

6

# Owl

The many short line strokes in this drawing create a soft, feathery texture in this owl drawing.

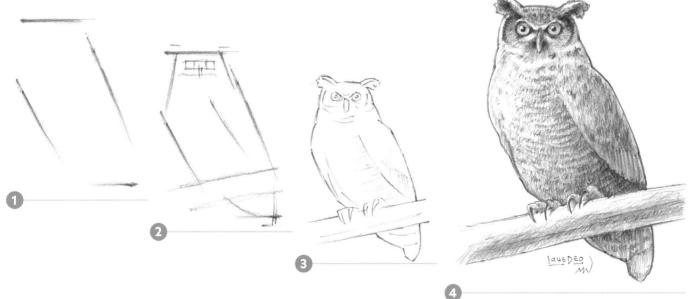

1

2

3

4

61

# Dog's Nose

Most of the structural sketch for this drawing is developed from circles and ovals. Notice the depth implied by having the dog's nose larger in proportion to the rest of its head.

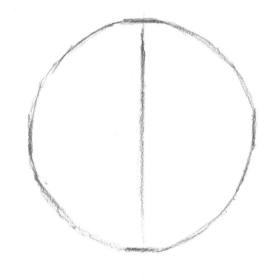

**1**

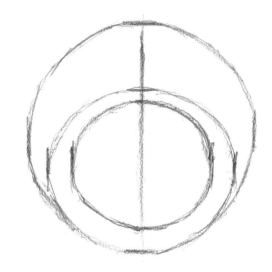

**2**

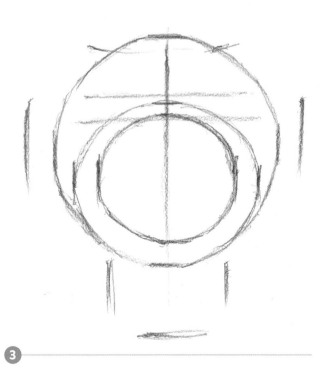

**3**

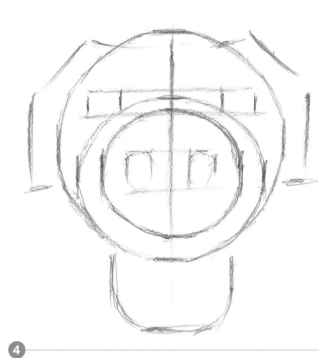

**4**

Animals

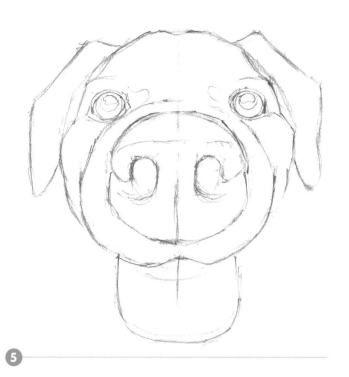

5

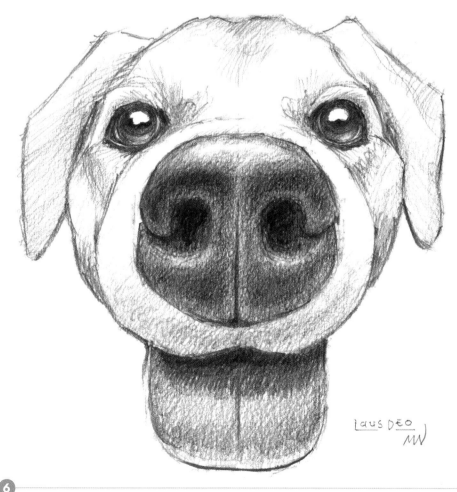

LAUS DEO
MW

6

# Dragon

Animals

To begin proportioning the wing, sketch a line arcing to the upper-right corner and continue forming and proportioning the wings in steps 2 through 5. Create depth by gradating the values from dark to light within each section of the wing.

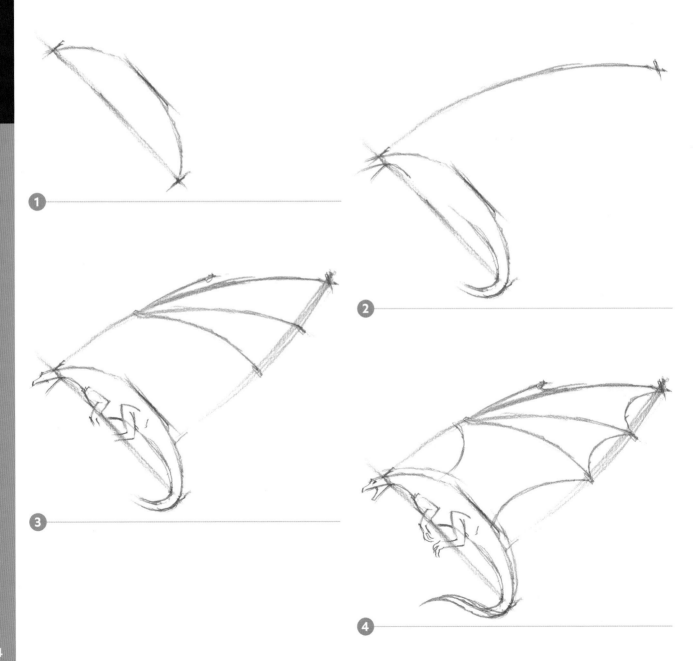

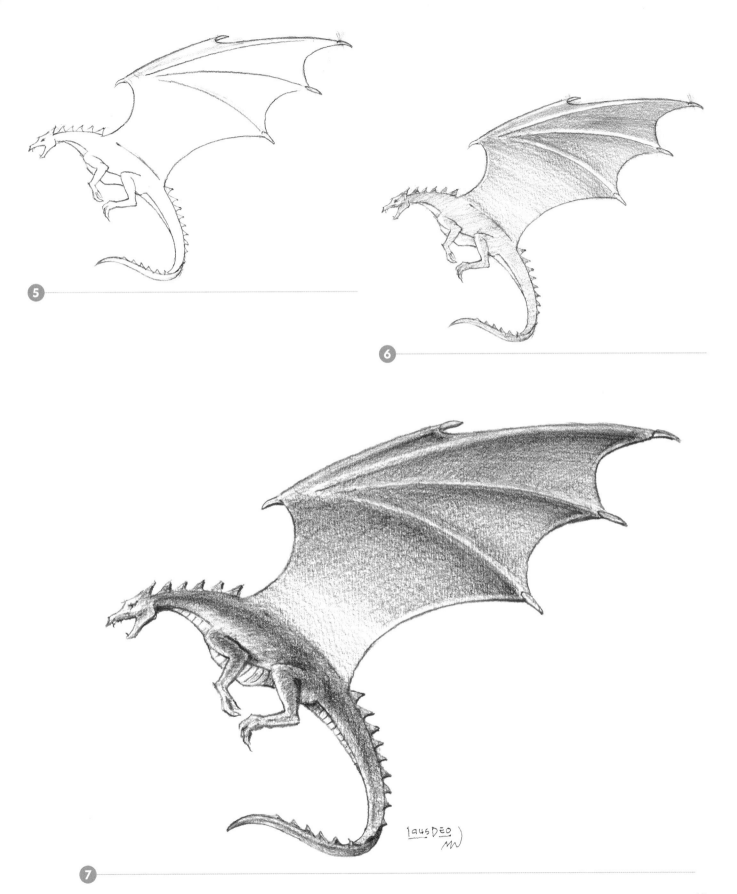

5

6

7

LausDeo

# Sea Turtle

Animals

For this sea turtle drawing, sketch a centerline to help keep the form of the shell symmetrical. To make the drawing process easier, the first 4 steps are drawn vertically. Then, to create more interest, crop the completed drawing at an angle.

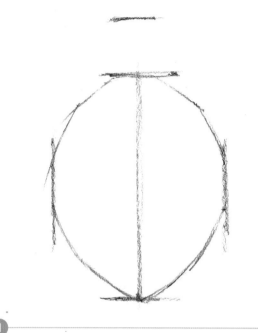

1

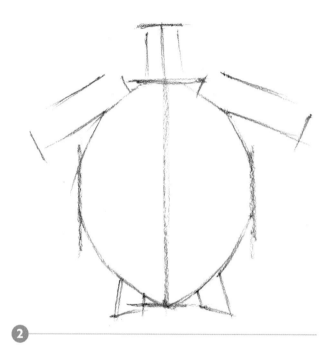

2

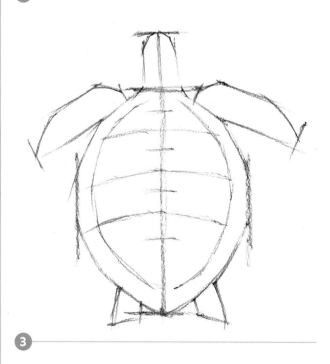

3

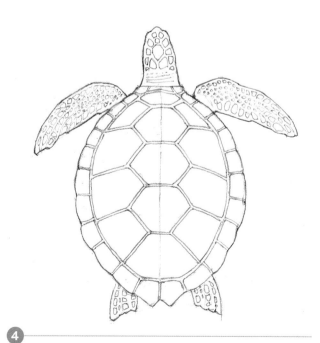

4

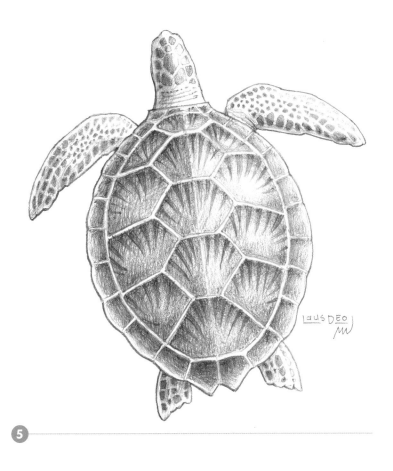

⑤

The outer dimensions of this viper are proportioned before sketching the curves of its body. Plan out the patterns of the skin while in the structural sketch stage, before adding the values.

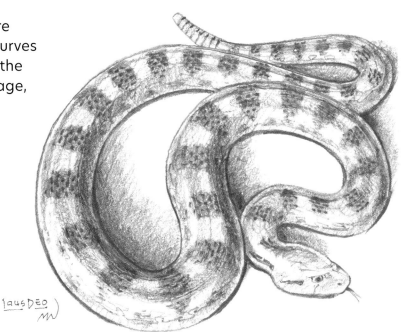

# Eye

While following the steps of this demonstration, set up a small mirror to examine and draw your own eye.

### ① Sketch and Proportion the Structure
Sketch a horizontal line to guide where the center of the eye is to be placed. Add proportioning lines for the top and bottom structure of the eye.

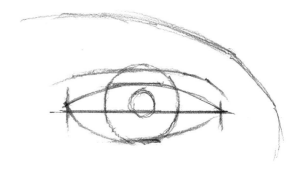
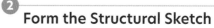

### ② Form the Structural Sketch
Sketch curved lines for the upper and lower eyelids. Add circles for the iris and the pupil. Add lines for the upper fold of the lid and the arch for the brow.

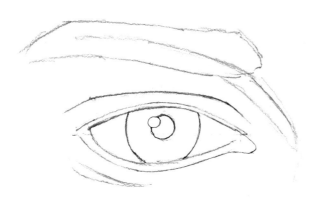

### ③ Add Details
Define the form of the eye, add lines to the upper and lower lids, and sketch the form of the brow. Sketch shadow lines.

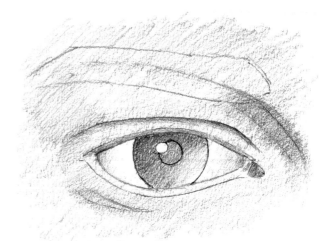

### ④ Add Light and Middle Values
With the light source from the upper left, add the light and middle values.

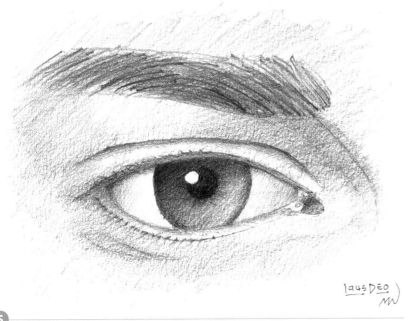

**⑤ Add Dark Values**
Add the dark values to complete the drawing.

# Mouth

With this drawing, note that the light is shining from above, which causes the top lip to be in shadow and the bottom lip to be in the light. The teeth are also in shadow and appear darker toward the corners.

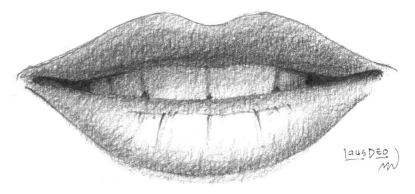

# Hand

While sketching this hand demonstration, use your own hand as a reference. Observe it as you follow the steps below.

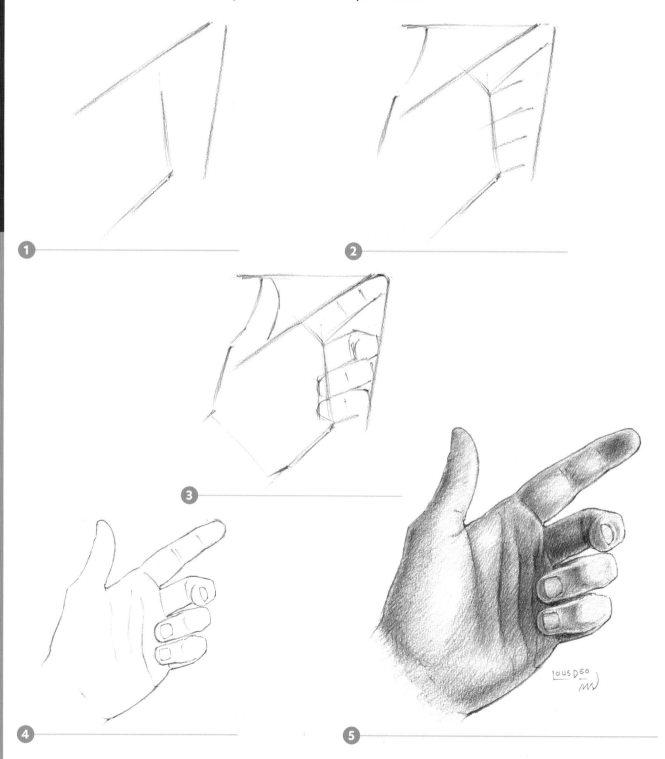

70

# Ear

After proportioning and sketching the outer form of the ear, add the folds and structural details. Values are added to create depth by shading the forward form of the ear lighter, and shading the recessed form darker.

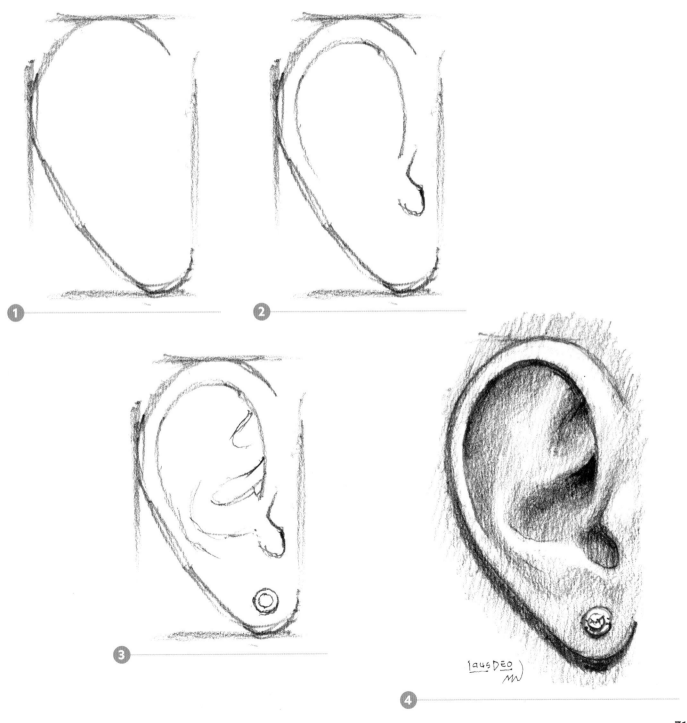

1

2

3

4

Correct proportions are foundational for successful drawing. When drawing a face, study the proportions in order to capture the unique aspects of each face that is drawn.

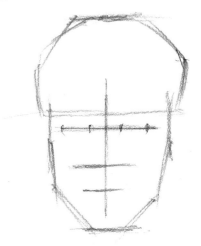

**1**

### Sketch the Proportion Lines

Sketch a horizontal line for the eyes. Draw a vertical line in the middle of the horizonal line. Sketch short lines for the proportions of the sides, top, and bottom of the head.

**2**

### Sketch the Shape of the Head, and Add Lines for the Features

Sketch the shape of the head. Add lines for the placement of the eyes, nose, mouth, and brow.

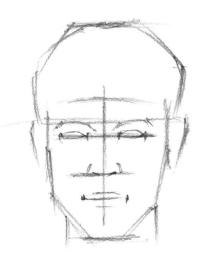

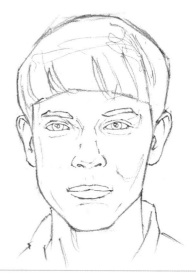

**3**

### Form the Features and Add the Ears, Hair, and Neck

Sketch the eyes, nose, and mouth. Add lines for the ears, hair, and neck.

**4**

### Add Details

Refine the sketch, adding details to the features, hair, and collar.

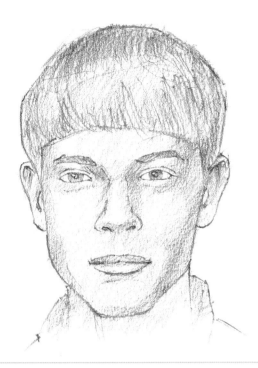

**5**

## Add Light and Middle Values

With the light source from the upper left, add the light and middle values, making the right side of the face more shadowed.

### EYES HALFWAY

The eyes are halfway between the top of the head and the bottom of the chin.

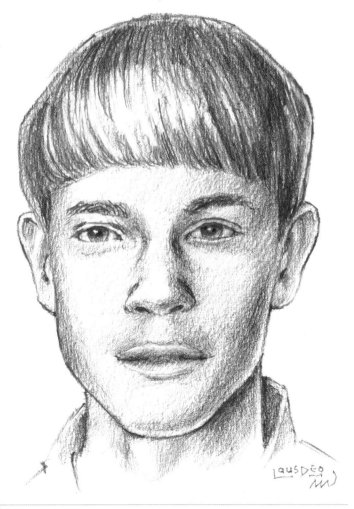

**6**

## Add Dark Values

Finish the drawing by adding the dark values.

# Knight

People

There is more to being a knight than slaying dragons—one must look the part. Customize your own version of a knight by looking at images of other knights. Then add what you like to create your own knight in shining armor.

### Sketch the Basic Proportions
Sketch lines for the base and top of the knight. Add a vertical line and a horizontal centerline. Sketch an oval for the head that is slightly more than 1/8 the total height of the knight.

**1**

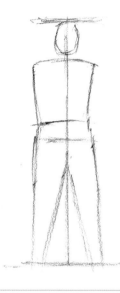

### Sketch the Upper Body and Legs
Sketch the basic shapes of the upper body. The lines for the legs proportionally make up the lower half of the body.

**2**

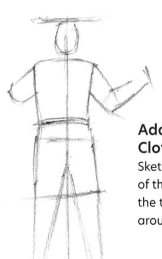

### Add the Arms, Clothing, and Belt
Sketch the basic shapes of the arms. Add lines for the tunic and the belt around the waist.

**3**

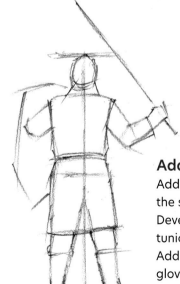

### Add Details
Add basic lines for the sword and shield. Develop the helmet, tunic, and chain mail. Add details to make the gloves that cover the arms and hand. Add the boots and breeches.

**4**

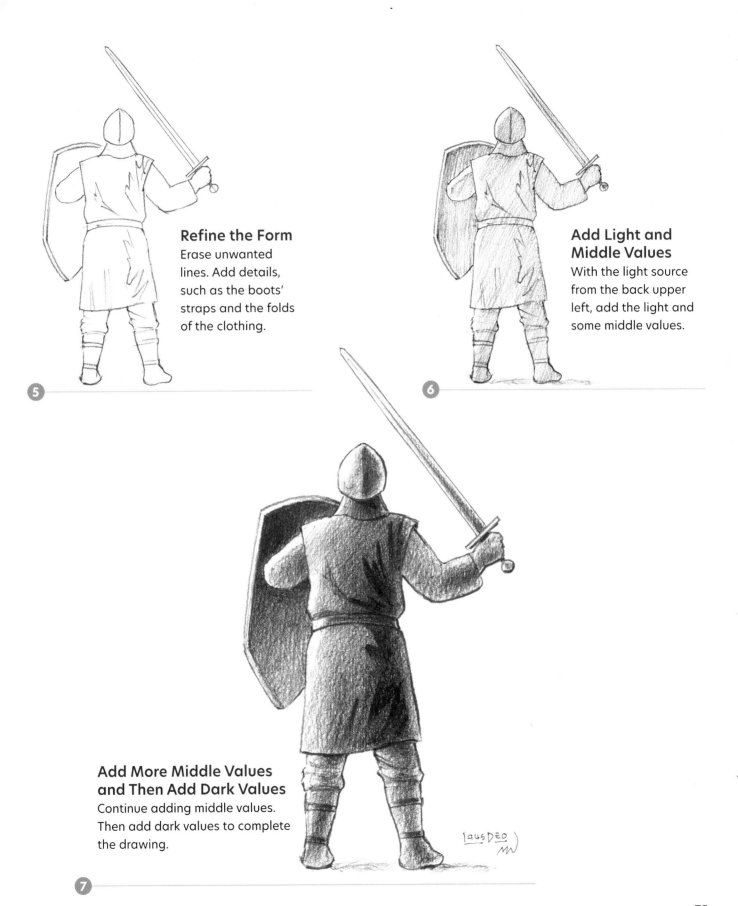

### Refine the Form
Erase unwanted lines. Add details, such as the boots' straps and the folds of the clothing.

**5**

### Add Light and Middle Values
With the light source from the back upper left, add the light and some middle values.

**6**

### Add More Middle Values and Then Add Dark Values
Continue adding middle values. Then add dark values to complete the drawing.

**7**

75

# Pirate

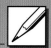
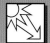

Aaargh, mateys! Notice that the eyes in this profile are placed halfway between the top of the head and the lower chin. The ear aligns with the brow and the base of the nose. Continue to check the proportions or suffer walking the plank!

### ① Sketch the Basic Proportions

Sketch lines for the top, bottom, front, and back of the head. Add a horizontal line for the eye that is halfway between the top and bottom lines.

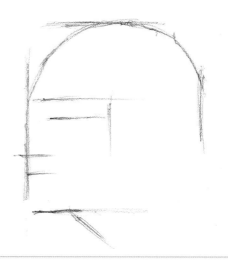

### ② Add Lines for the Features

Sketch horizontal lines for the nose, mouth, and brow. Sketch a vertical line for the ear and a diagonal line for the neck.

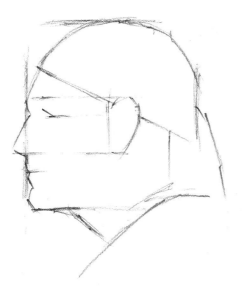

### ③ Form the Features

Sketch the profile of the head. Sketch the eye, ear, shoulder, and bandanna.

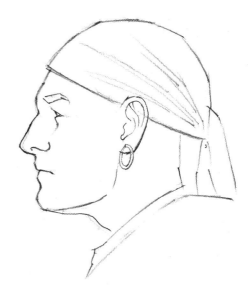

### ④ Refine the Form

Erase unwanted lines, and begin adding details to the features.

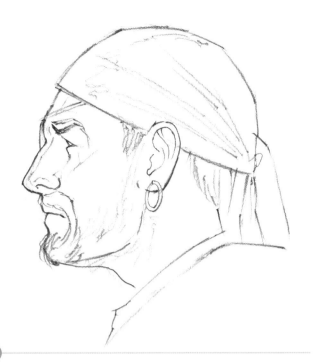

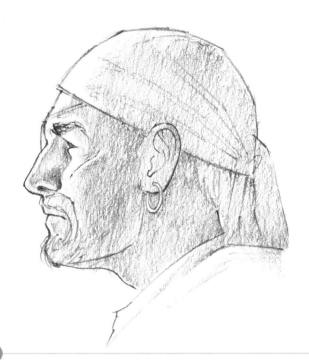

## 5

### Add Details

Add lines to the hair, beard, eye patch, scar, and bandanna.

## 6

### Add Light and Middle Values

With the light source from the upper left, add the light and middle values.

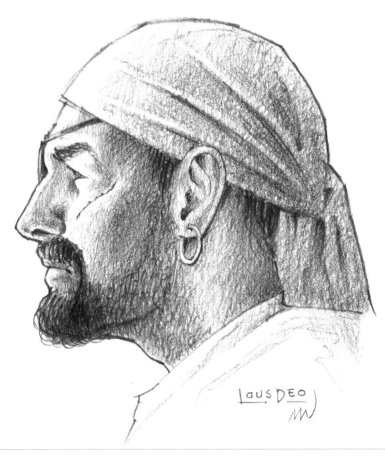

### Add More Middle Values and Then Add Dark Values

Continue adding middle values. Then add the dark values to complete the drawing.

## 7

People

Examine your own hand while drawing this. With no external light source, the denser areas, such as the bones, appear lighter.

**1**

### Measure and Proportion
Look for the basic shapes as you measure and proportion your hand with the 2B pencil. Sketch the outer form of your hand, including the fingers and thumb.

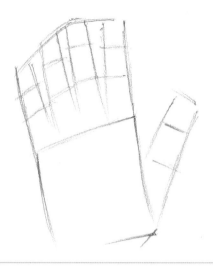

**2**

### Form the Hand
Sketch the fingers, and add lines for the knuckles.

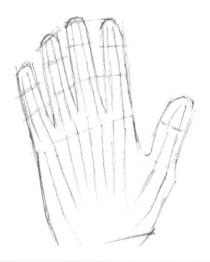

**3**

### Sketch the Bones
Add lines for the basic shapes of the bones within the hand. You can feel the bone structure of your hand to aid in this step.

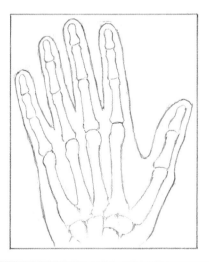

**4**

### Refine the Forms and Add Details
Erase unwanted lines, refine the forms, and add details to the structural sketch.

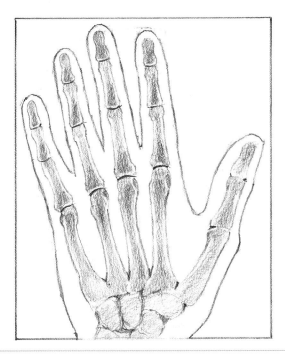

**5**

## Add Light Values
Add values to the bones, leaving some ares white.

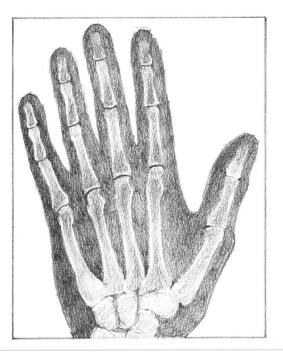

**6**

## Add Middle Values
Add values that are darker than the bones to the hand.

### YOUR ARTWORK IS UNIQUE!
Just like your fingerprint, the creative process is personal, and your artwork will be one of a kind!

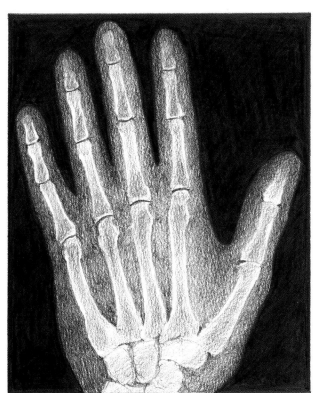

## Add Darkest Values
Using the 8B pencil, create the background by adding the darkest values.

**7**

# Arch

A vertical centerline is used in the structural sketch to keep the arch symmetrical.

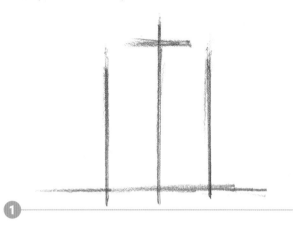

1

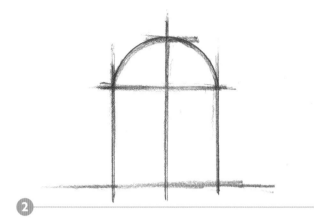

2

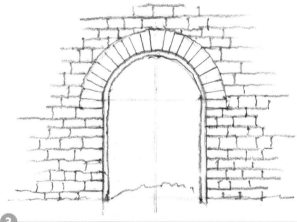

3

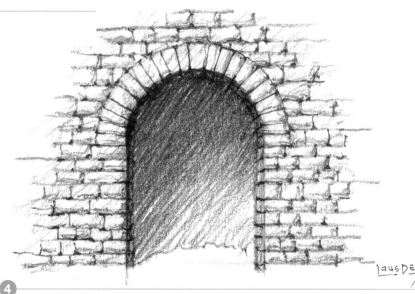

4

# Eiffel Tower

Start with a horizontal line for the base and a vertical centerline for the tower.

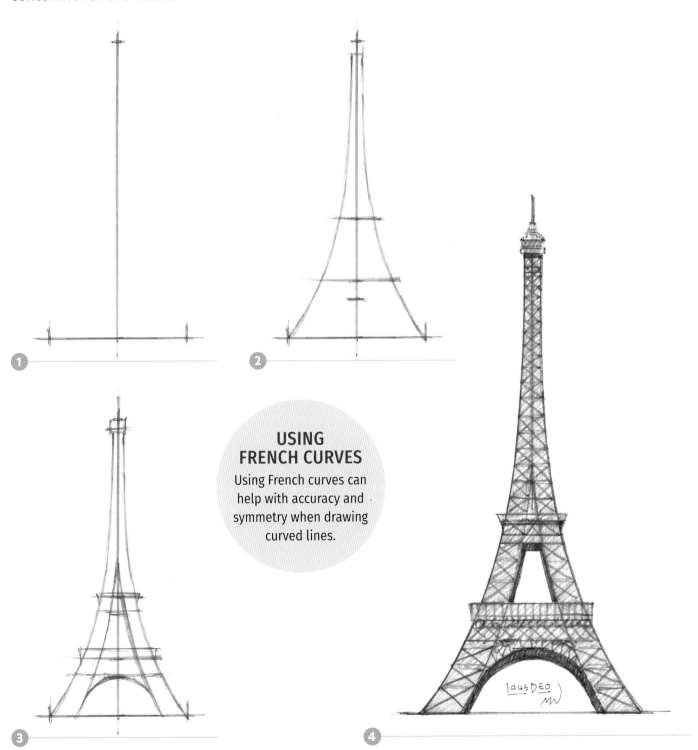

**USING FRENCH CURVES**

Using French curves can help with accuracy and symmetry when drawing curved lines.

# Barn

Though this demonstration uses two-point perspective, the barn can be drawn without having to plot out the vanishing points.

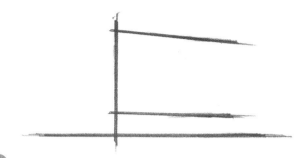

## 1 Sketch the Right Side of the Barn

With a 2B pencil, sketch a horizontal line near the bottom of the page for the horizon. Sketch a vertical line for the forward-most corner. Add two lines that gently slope to the right toward the horizon.

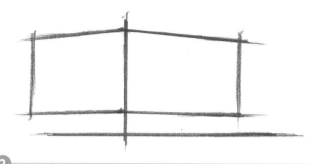

## 2 Form the Sides of the Barn

To the left of the corner line, add two lines that gently slope toward the horizon. Sketch a vertical line on the left and one on the right to form the sides.

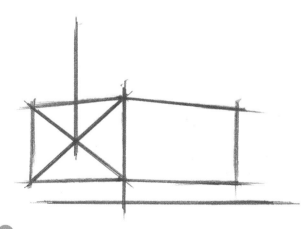

## 3 Create a Centerline

Connect the corners of the left side to form an X. Sketch a vertical line upward from the cross point as the centerline.

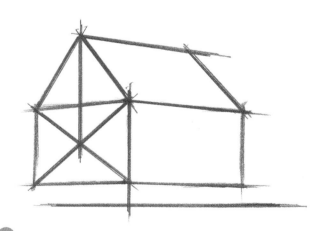

## 4 Add the Roof

Sketch two lines down from the centerline to the two corners of the barn on the left side. From the roof peak, add a line to the right and another line to the far right to form the roof.

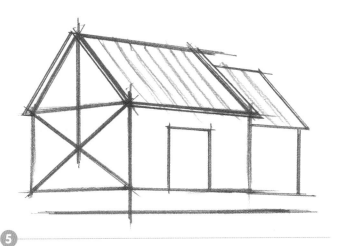

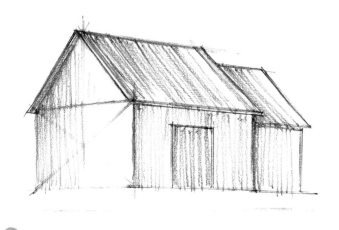

## 5 Add Details

Extend the edges of the roof to create overhangs. Create a barn addition on the right by following the previously sketched lines. Erase unwanted lines, and add structural details.

## 6 Add Light and Middle Values

With the light source from the upper left, add the light and middle values.

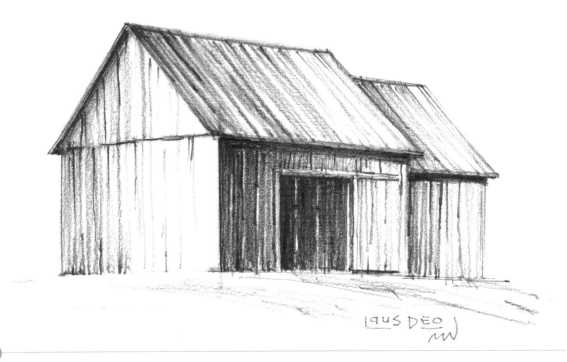

## 7 Add Darkest Values

Add the darkest values with the 8B graphite pencil. Look to see if any areas need to be lightened, which can be done by lifting graphite with the kneaded eraser.

# Lighthouse

A vertical centerline keeps the sketch of this lighthouse tower symmetrical. Use the mechanical pencil for the thinnest lines of the architectural details, such as the lightning rod and railing.

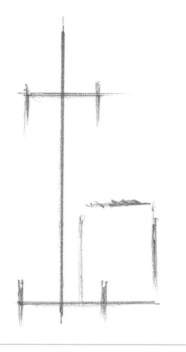

**1**

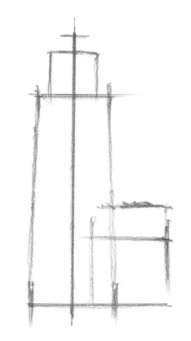

**2**

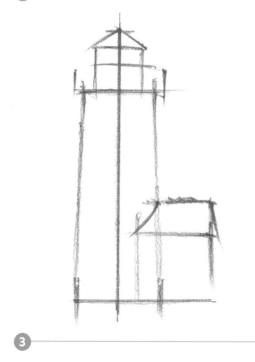

**3**

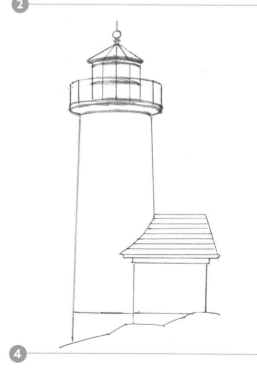

**4**

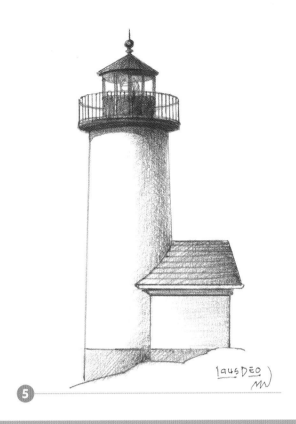

5

# Hollywood Sign

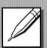 

Top and bottom guidelines are used for the placement of the letters in this drawing of the iconic Hollywood sign.

1

2

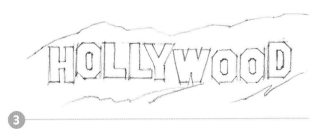

3

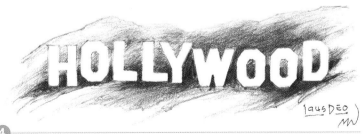

4

# Castle

Simple rectangular shapes added to one another form the structure of the castle. The light source, which is from the back upper left, highlights the left side of the features of the castle.

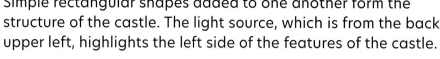

1

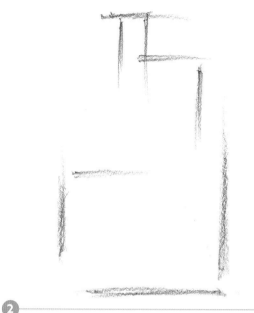

2

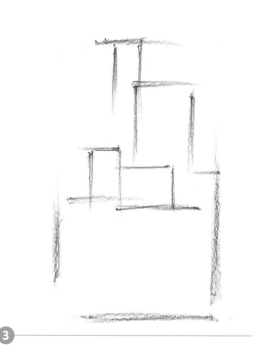

3

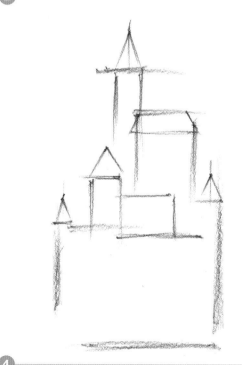

4

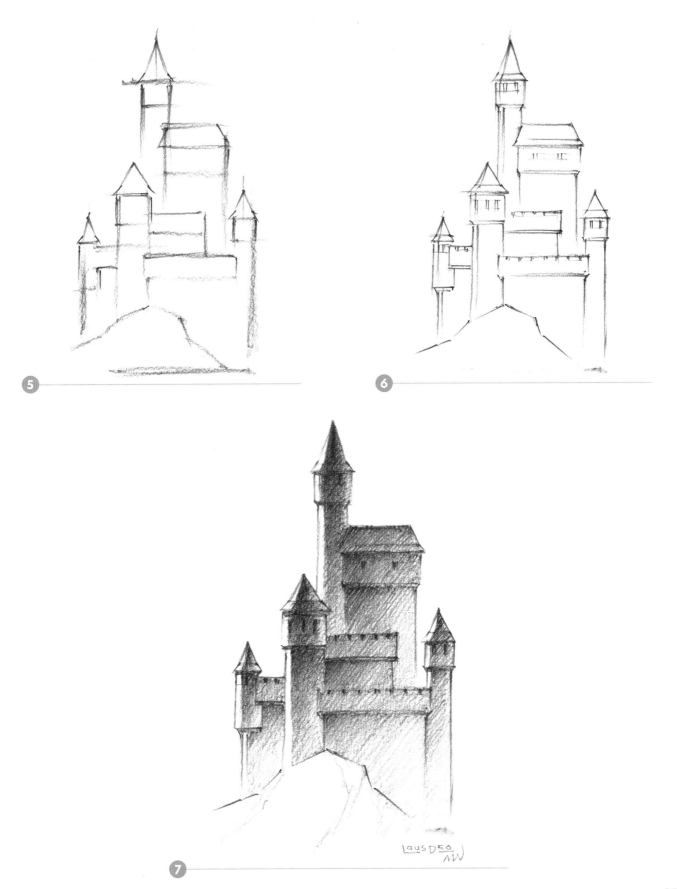

5

6

7

# Main Street

The Main Street and Mine Shaft (page 89) drawings are both developed from square and rectangular forms.

## USING PENCIL WITH PEN

When drawing with a pen, one approach is to work out the structural sketch with a graphite pencil, and then go over the lines that are to be kept with a pen. Erase unwanted pencil lines after values are added with the pen.

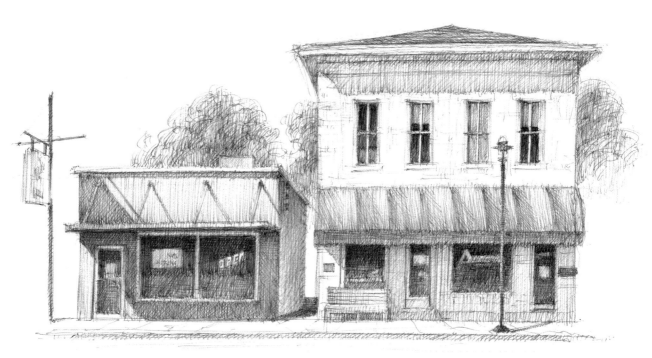

# Mine Shaft

Create depth for this mine shaft drawing by using rich, dark values applied with the 8B graphite pencil.

1

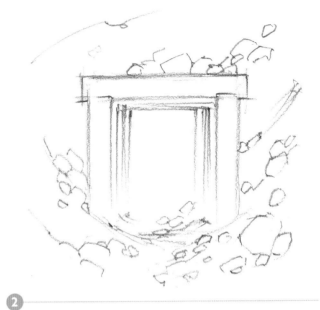

2

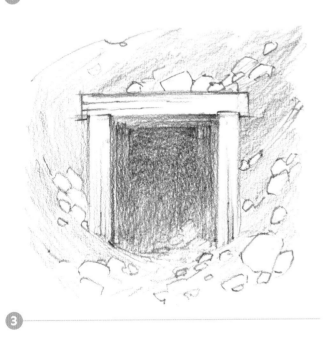

3

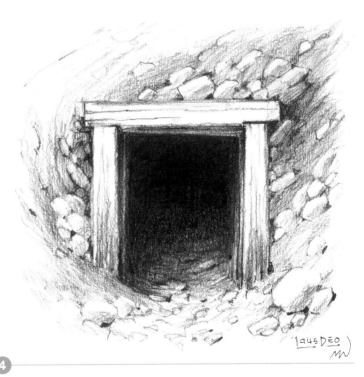

4

# Hot Air Balloon

A vertical centerline is used to proportion the outer form of the balloon. When adding the curved lines, start near the center and work toward the edges of the balloon. The horizontal stripe is drawn with slightly curved lines, which give the impression of a balloon filled with air.

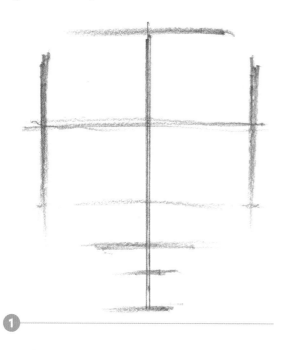

1

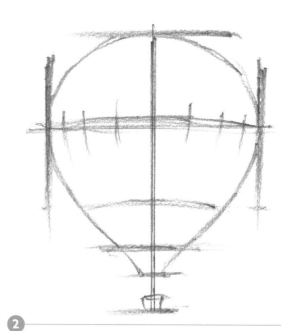

2

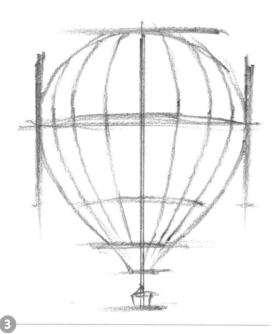

3

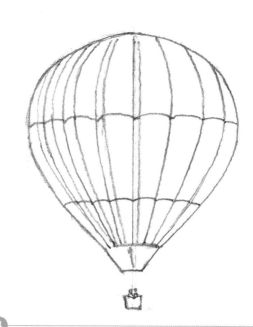

4

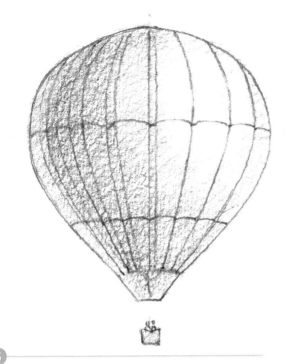

5

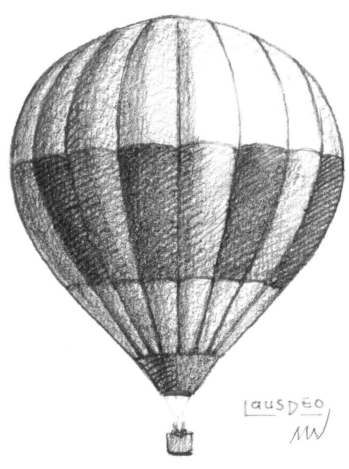

LAUSDEO

6

# Airplane

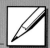 

Before sketching, study the finished drawing to keep the end result in mind. The lines of the wings and fuselage start out straight, but are then curved while creating the structural sketch.

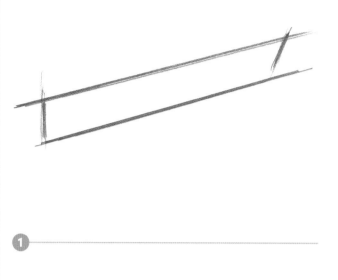

**1**

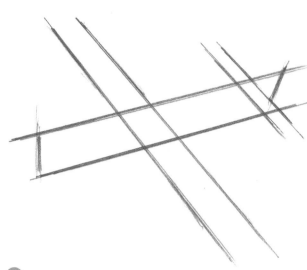

**2**

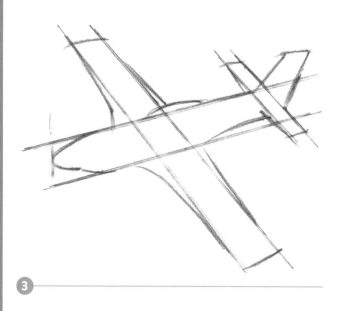

**3**

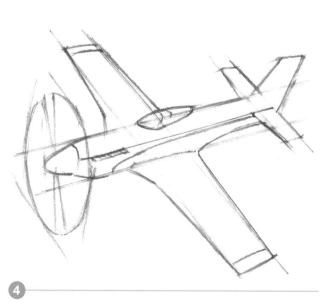

**4**

92

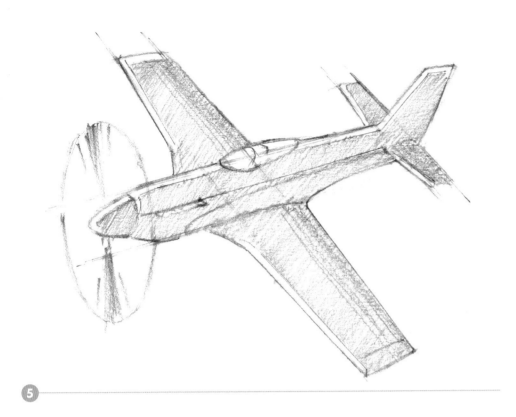

5

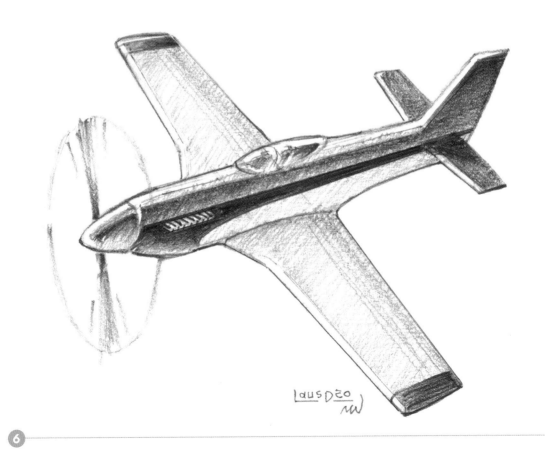

6

# Truck

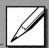

Have fun creating textural effects for this truck. Use sketchy, multidirectional strokes to give it a weathered appearance.

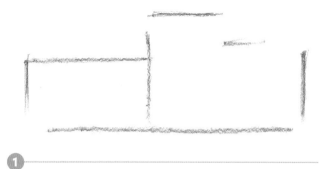

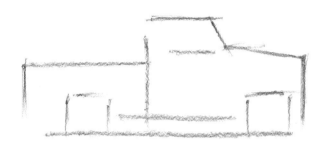

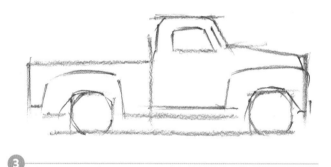

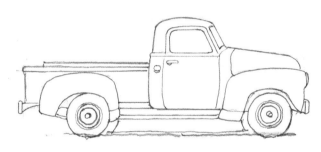

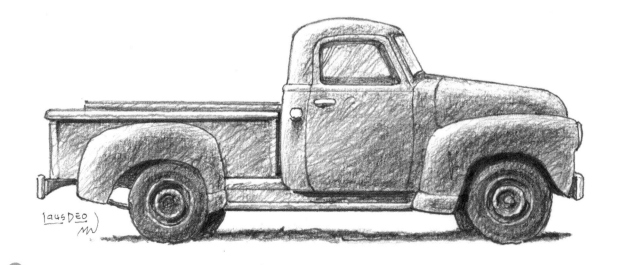

**Transportation**

# Zeppelin

Like big silver pickles floating in the sky, zeppelins were giant airships with ridged metal frames. While most of this image will be drawn with the 2B graphite pencil, use a mechanical pencil to add the detailed linework.

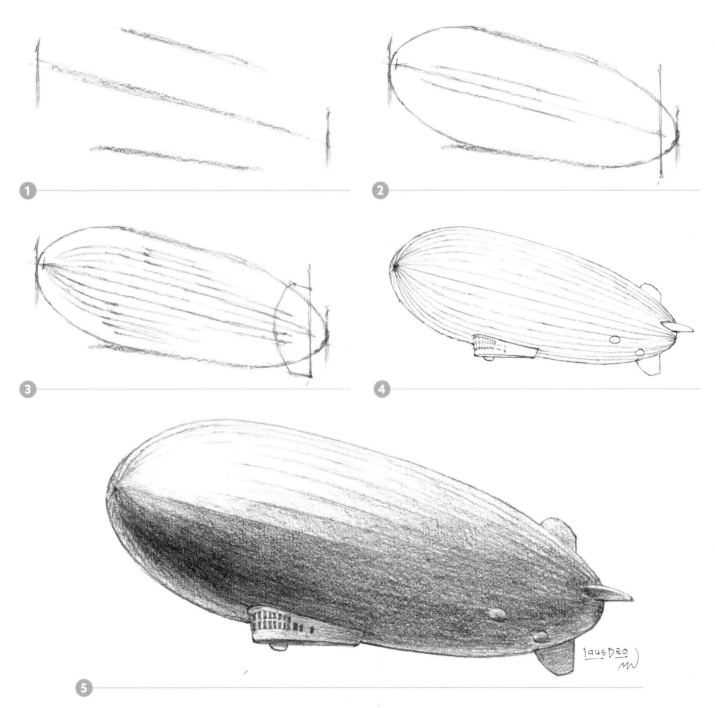

# Van

What's a 1960s van without psychedelic graphics?
Add your own design to your drawing after completing
most of the structural sketch.

1

2

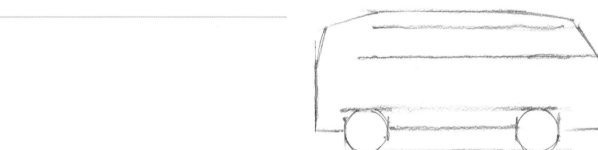

3

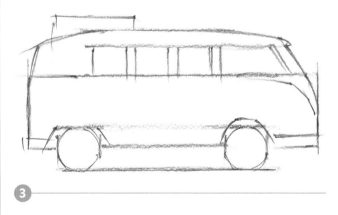

4

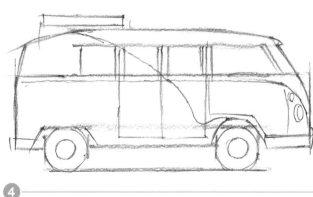

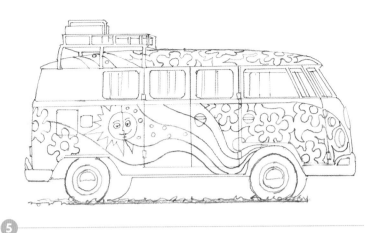

5

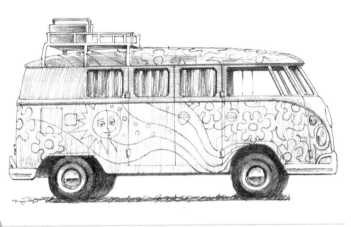

6

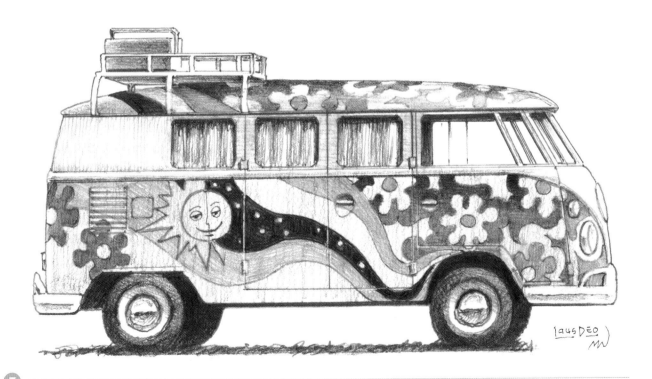

7

Transportation

A ruler may be helpful when drawing the straight lines of the boat's hull, mast, sails, and other structural details.

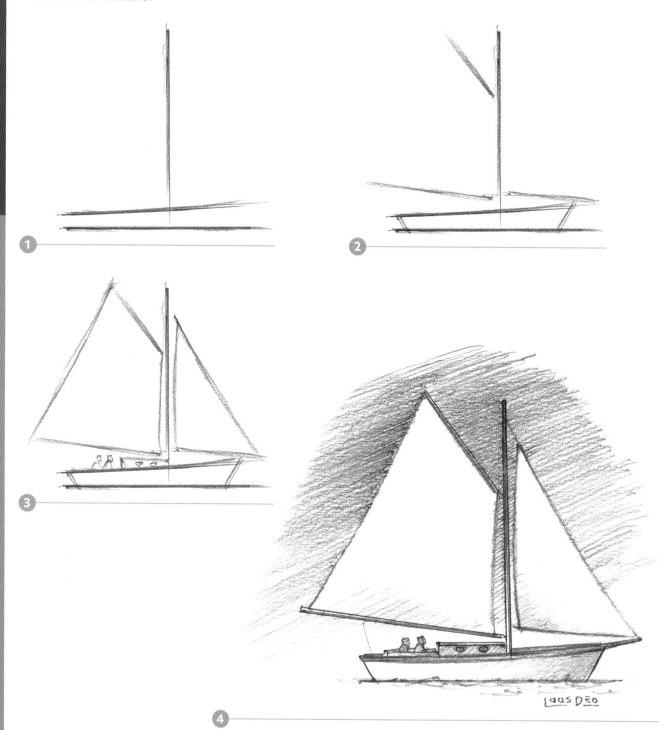

# Chapter 3
# Put It Together

Each of these composition drawings combine several demonstrations previously learned in chapter 2.

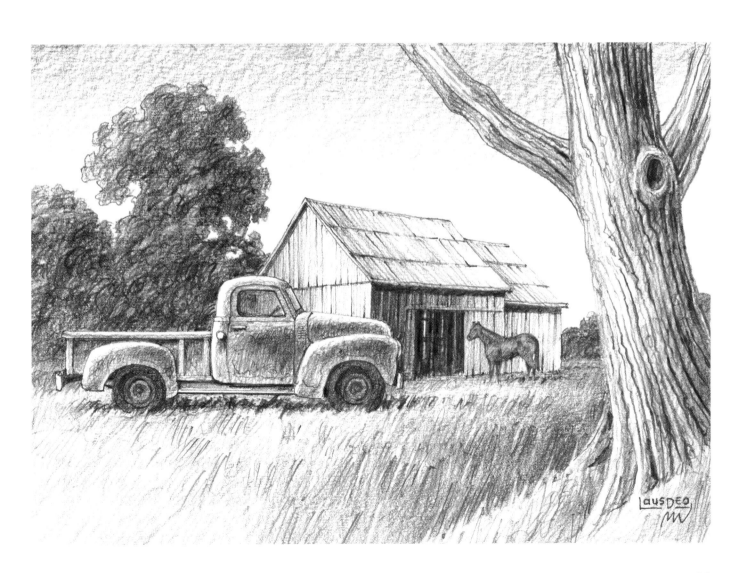

# Cove Scene

Refer to the Boat (page 98), Lighthouse (page 84), and Rocks (page 48) demonstrations from chapter 2 for more detailed instructions for the elements in this scene.

Use the 2B pencil for most of the linework and values. For the details, such as the lighthouse railing and boat rigging, use the mechanical pencil.

**1**

### Sketch the Shore and the Rocks
Sketch a line for the shore where the water meets the rocks. Add lines for the basic shapes of the rocks.

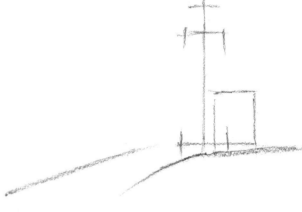

**2**

### Proportion the Lighthouse
Sketch a horizontal baseline for the lighthouse and a vertical centerline for the tower. Add proportion lines for the tower and mud room.

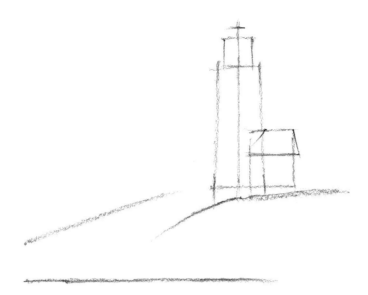

**USING A SLIP SHEET**
Sometimes during the process of drawing, the side of the hand may smear the graphite. To avoid this, use a plain piece of paper as a slip sheet.

**3**

### Form the Lighthouse
Sketch the shapes of the tower, lamp room, and mud room.

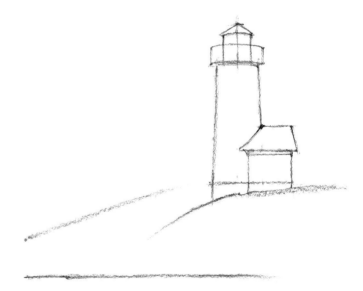

### Add Details
Erase unwanted lines. Add the deck, the roof to the tower, and the roof to the mud room.

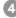 **4**

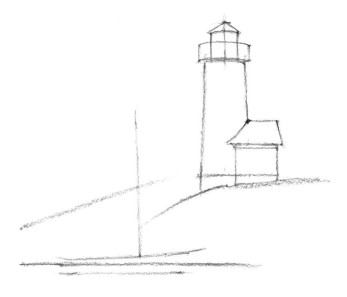

**5**

## Sketch the Boat

Begin sketching lines for the hull and the mast
of the boat.

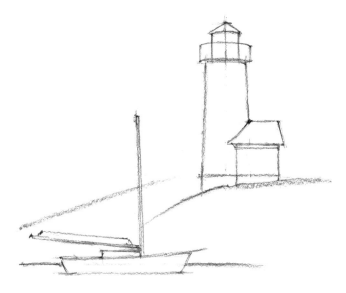

## Add Details to the Boat

Erase unwanted lines. Sketch
lines to complete the hull and
add the cabin.

**6**

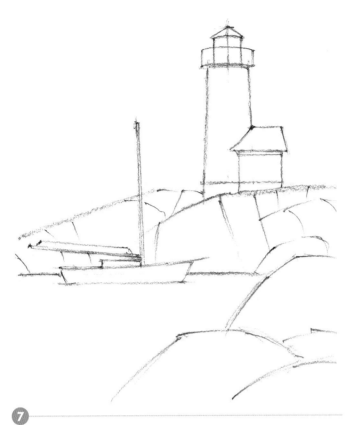

**7**

## Add Details to the Rocks

Add the foreground rocks. Then add the details to the rocks, working from the largest to smallest rocks.

### SKETCHING WHAT ISN'T SEEN

When drawing an object that is blocked from view by something in front of it, sketch the full form of the object to ensure that it is drawn accurately, then erase the part that isn't to be included in the drawing.

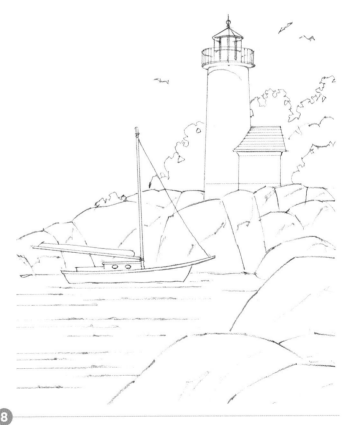

**8**

## Refine and Add Details

Erase unwanted lines. Add details to the lighthouse, boat, and rocks. Add the foliage, waves, and seagulls.

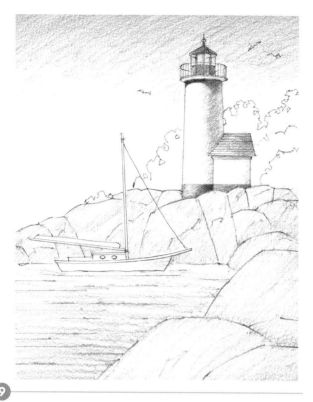

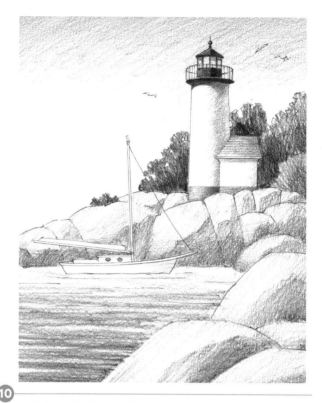

**9** Add Light Values

With the light source from the upper left, begin adding values, starting with the lightest areas, such as the tower of the lighthouse.

**10** Add Middle and Dark Values

Continue adding values throughout the scene. Gradated shading added in areas such as the sky and water will add a realistic appearance to the finished drawing.

## LEADING THE EYE

Intentional use of contrasting values is one way to create focal points in a scene. By having dominant and less dominant focal points, the viewer's eye is led from one element to another through the drawing's composition.

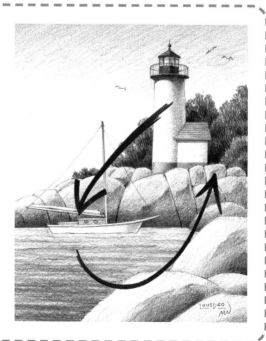

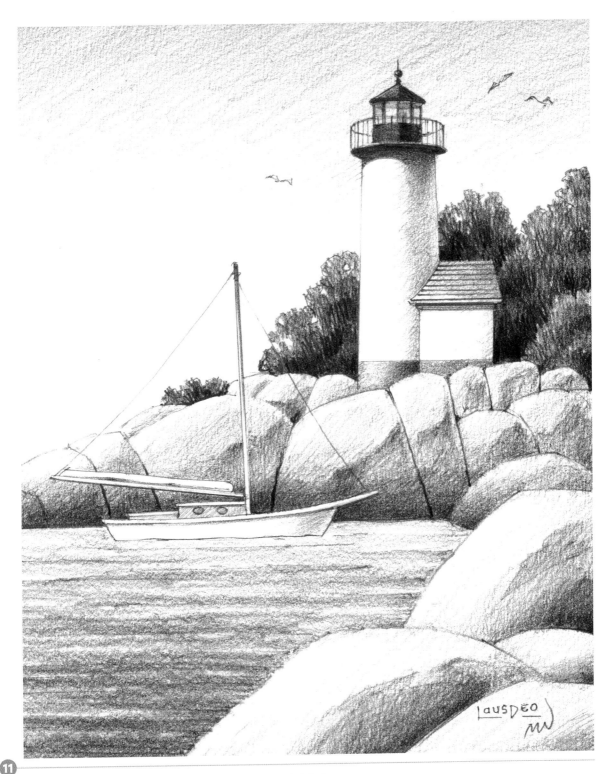

**11**

## Create Light Areas and Add More Dark Values

Lift the graphite lead with a kneaded eraser to create light areas, such as the waves on the water. Add dark values to complete the drawing. Sign and date your drawing.

Rocky Cove
Graphite pencil on drawing paper
8" x 6 ½" (20cm x 16cm)

# Interior Scene

Refer to the Couch (page 28) and Flames (page 24) demonstrations for more detailed instructions for this composition.

It may be helpful to use a ruler in this one-point perspective scene to direct the lines that are to go to the single vanishing point, which is placed at the center of the drawing.

**1**

### Sketch the Back Wall and Mark the Vanishing Point

Sketch a rectangle for the back wall of the room. Place a dot in the center of the scene as the vanishing point.

### Add Corner Lines

Sketch lines from the vanishing point to each of the four corners of the rectangle to create the corners of the room.

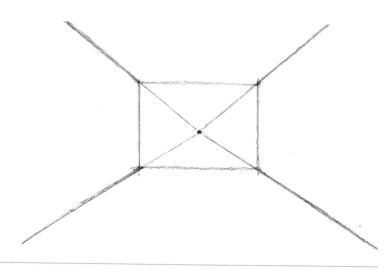

**2**

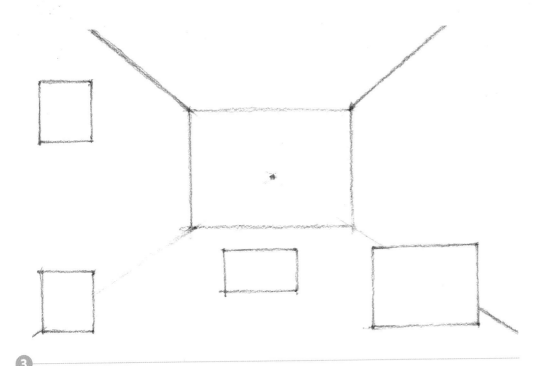

**3**

## Sketch the Sides of the Furniture

Sketch rectangles as the front-facing sides of the cabinets, table, and couch. Erase unwanted lines as the sketch progresses.

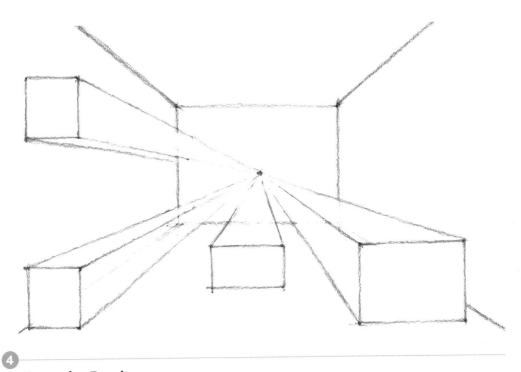

**4**

## Form the Furniture

Sketch lines from the corners of the cabinets, table, and couch to the vanishing point to define the shapes of the furniture.

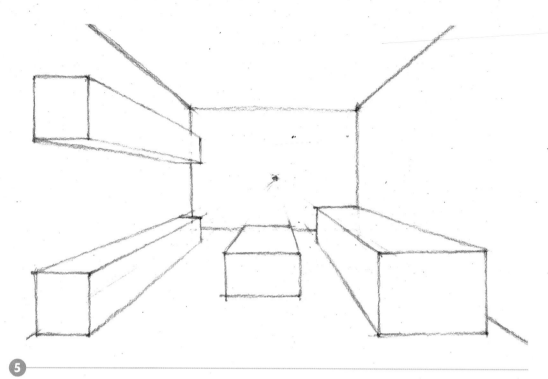

**5**

## Add Details to the Furniture

Add vertical and horizontal lines to the cabinets, table, and couch to form box shapes.

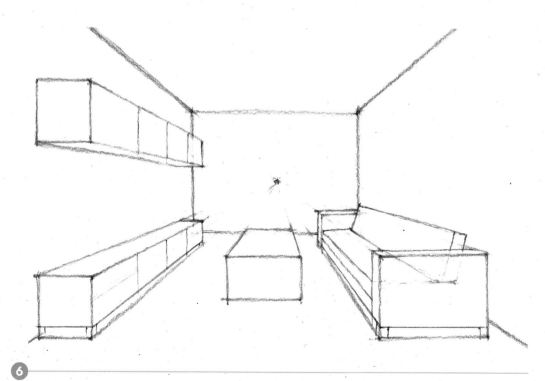

**6**

## Continue to Add Details to the Furniture

Add details to further develop the cabinets, table, and couch.

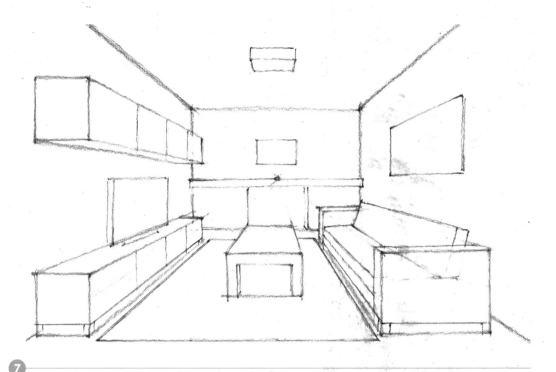

**7**

### Add the Décor

Sketch the TV, wall hangings, rug, ceiling light, mantle, and a rectangle for the fireplace.

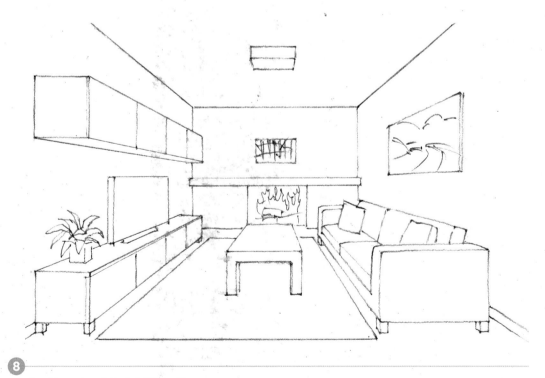

**8**

### Refine and Add Details

Erase unwanted lines. Add more décor details, such as the potted plant, fire, couch pillows, and paintings.

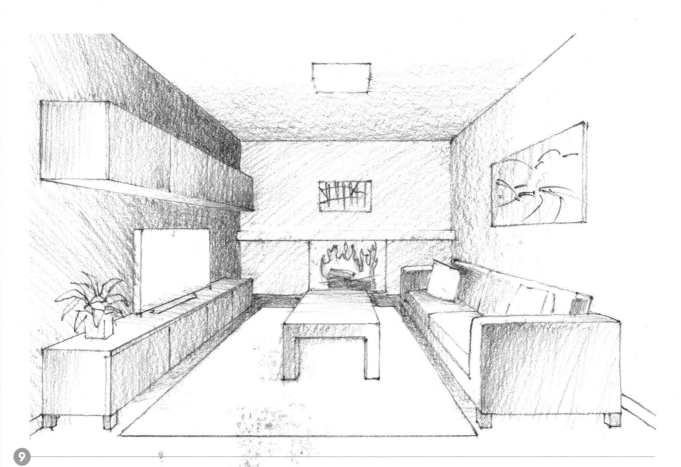

**9**

## Add Light and Middle Values

With the light source from the upper left, add the light
values. Begin adding the middle values.

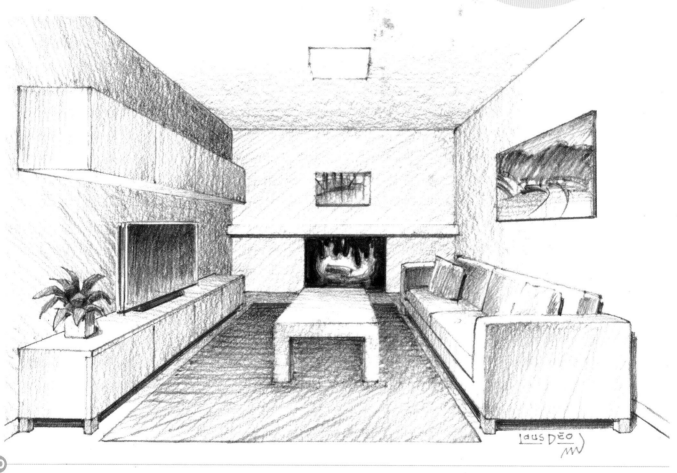

⑩

## Add More Middle Values and Add Dark Values

Continue adding the middle values. Then add dark values to complete the drawing. Sign and date your drawing.

Home Away from Home
Graphite pencil on drawing paper
4 ½" x 7 ½" (12cm x 19cm)

# Still Life Composition

This still life demonstration is used as an example for how to measure, proportion, and align elements (pages 12-13). There are more detailed instructions for the Mug (page 35), Apple (page 38), and Grapes (page 43). Set up your own still life. Remember to note the direction of your light source for the placement of the lights and darks.

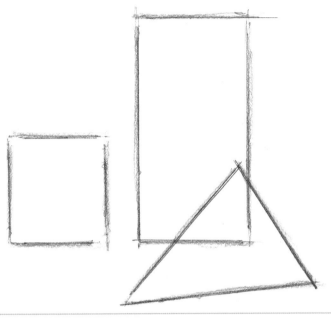

**1**

### Proportion the Mug, Apple, and Grapes
Look for the basic shapes in the still life. Proportion and sketch the basic shapes for the mug, apple, and grapes.

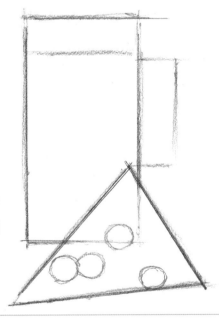

**2**

### Sketch the Elements
Add lines for the top and handle of the mug and the outer form of the apple. Add small ovals for several of the individual grapes.

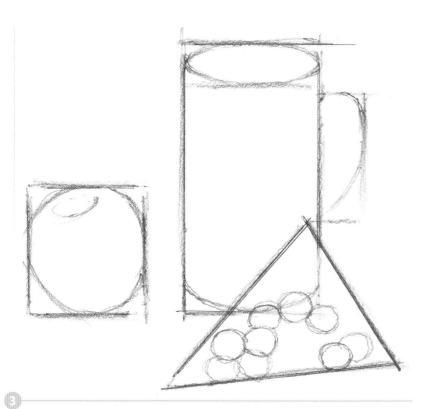

③

## Refine the Elements

Create ellipses and curved lines for the mug and apple. Then add more small ovals for the grapes.

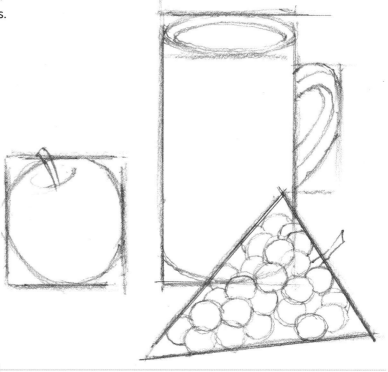

④

## Add Details to the Elements

Continue to add details to the mug, apple, and grapes.

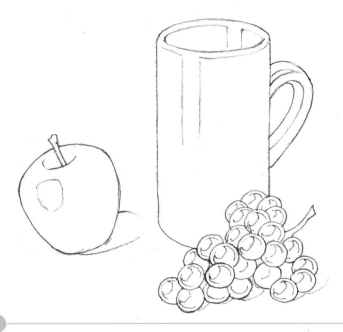

**⑤**

### Refine the Elements

Erase any unwanted lines. Then refine the elements in
the still life. With the light source from the upper left,
add lines indicating the highlights and shadows.

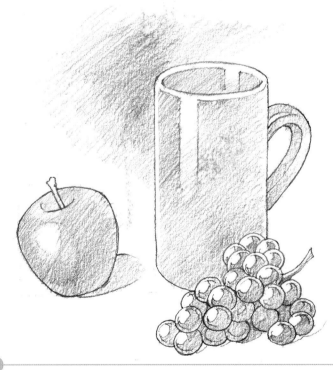

**⑥**

### Add Light Values

Leaving the lightest values the white of the paper,
begin adding light values to the mug, apple, and
grapes and to the background.

# FUN WITH CONTOUR DRAWING

One way to study the structure,
contours, and values of a
drawing is to create a contour
drawing. Also known as
continuous line drawing, contour
drawing involves putting a pencil
to the paper and, without lifting
the pencil, draw the shapes and
shadows that are evident in the
subject. For an added challenge,
block the view of the paper
with a piece of cardboard while
creating what is known as a
blind contour drawing.

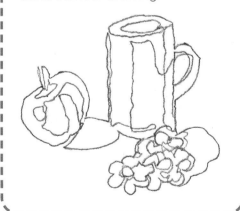

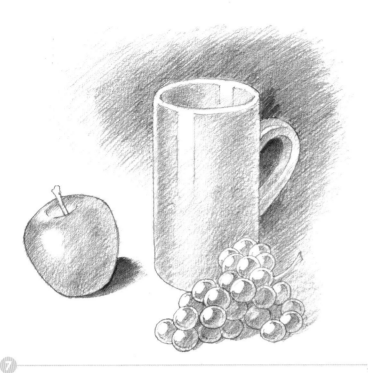

## Add Middle Values and Then Add Dark Values

Add the middle values to the mug, apple, and grapes and to the background. Begin adding dark values.

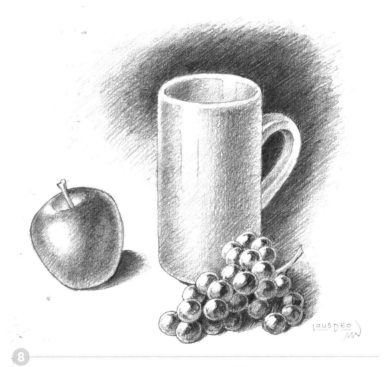

## Continue Adding Middle and Dark Values

Continue adding the middle and dark values to complete the drawing. Sign and date the drawing.

*Still Life with Apple, Mug, and Grapes*
Graphite pencil on drawing paper
5 ½" x 6" (14cm x 15cm)

# Desert Scene

For this drawing, the Hot Air Balloon (page 90), Cactus (page 44), and Mountains (page 45) can be referred to for more details.

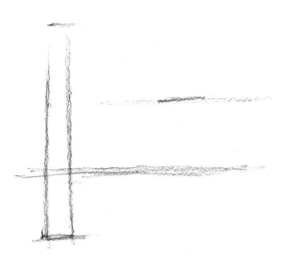

### 1 Sketch the Proportion Lines

Sketch a horizontal line for the base of the mountains and another for the peak of the highest mountain. Sketch two vertical lines for the trunk of the largest cactus, and add short horizontal lines for its bottom and top.

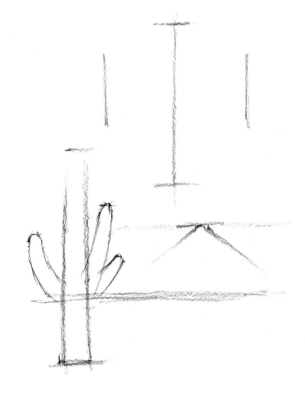

### 2 Sketch the Basic Shapes and Proportion the Hot Air Balloon

Add limbs to the cactus, and sketch the closest mountain. Sketch a vertical centerline for proportioning the largest hot air balloon, and add lines to shape the outer proportions.

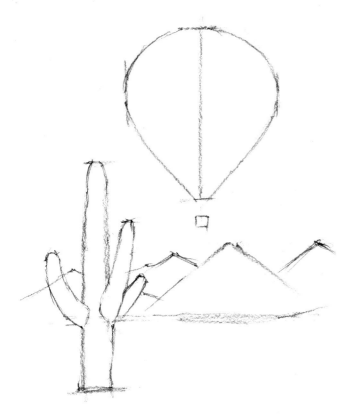

**REFER TO REFERENCE MATERIALS**
Finding reference materials of a subject, such as photos, is helpful for observation.

**3**

### Form the Mountains, Cactus, and Hot Air Balloon

Sketch the forms for the other mountains, the cactus, and the hot air balloon. Erase unwanted lines throughout the process.

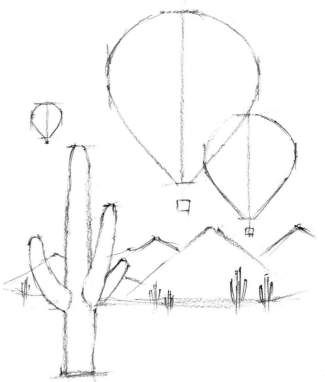

**4**

### Add Cacti and Balloons

Sketch the basic shapes of the additional cacti and hot air balloons.

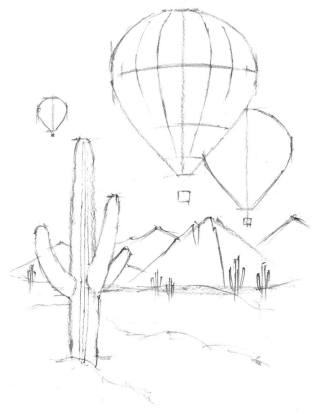

**5**

### Add Details

Add details to the cacti, mountains, hot air balloons, and foreground. As these elements are sketched, include subtle design changes to make each element unique.

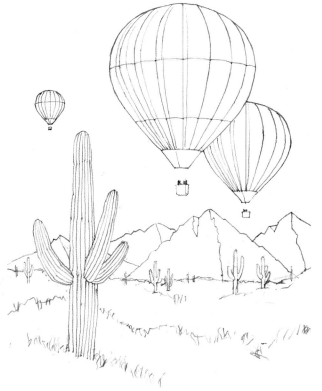

**6**

### Refine and Add More Details

Refine the cacti, mountains, and hot air balloons. Add details, including the grasses in the foreground. With the light source from the upper right, add lines for the shadows on the mountains and balloons.

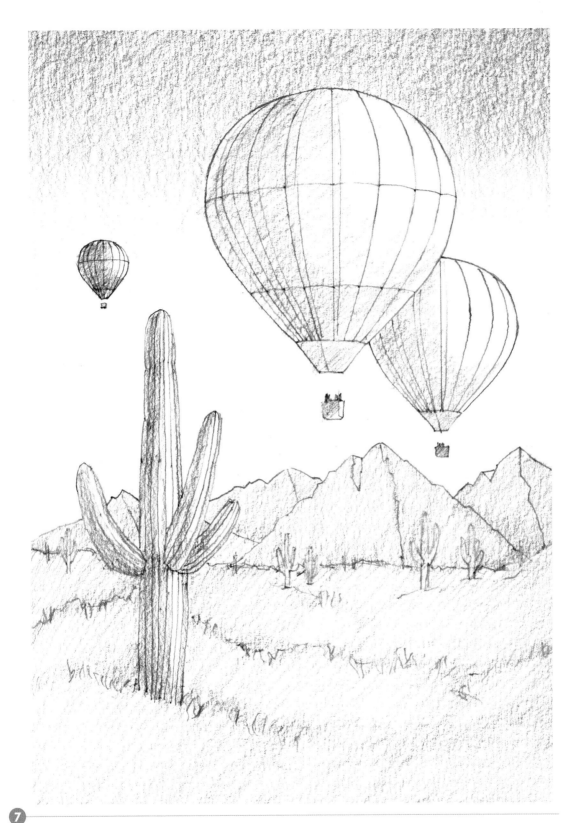

**7**

## Add Light Values

Add light values to the elements. The shading of the sky
gradates to white before it reaches the smallest balloon.

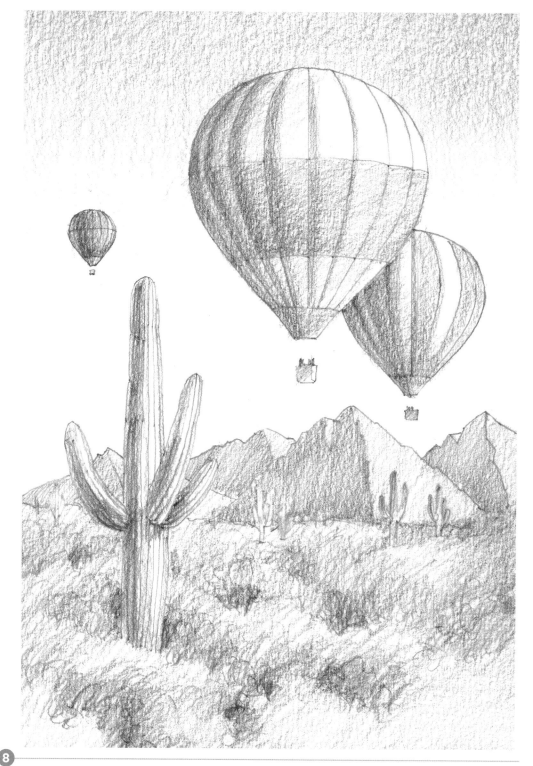

**8**

## Continue Adding Light and Middle Values

Add the light and middle values to the cacti and hot air balloons
and throughout the composition of the scene.

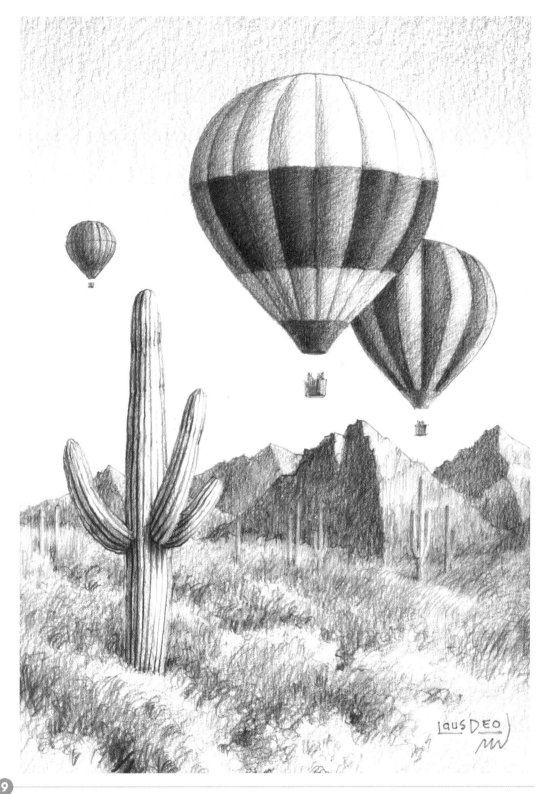

**9**

## Add Dark Values
Add the dark values to complete the drawing.
Sign and date your drawing.

Up, Up, and Away
Graphite pencil on drawing paper
9" x 6" (23cm x 15cm)

# Castle Scene

Look for the demonstrations of the Castle (page 86), Dragon (page 64), and Knight (page 74) for additional guidance for this scene.

Because the light source is behind the subjects from the upper left, the values of the castle, dragon, knight, and rocks are mostly dark with areas that are lighter on the upper left.

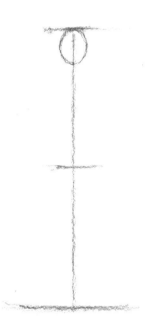

**1**

### Proportion the Knight
Sketch lines at the base and top of the knight's body. Add a vertical line, a horizontal line at the center, and an oval for the head.

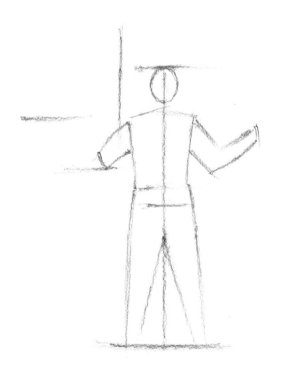

**2**

### Sketch the Knight's Features and Proportion the Castle
Sketch the torso, legs, and arms of the knight. Add lines for the outer proportions of the castle.

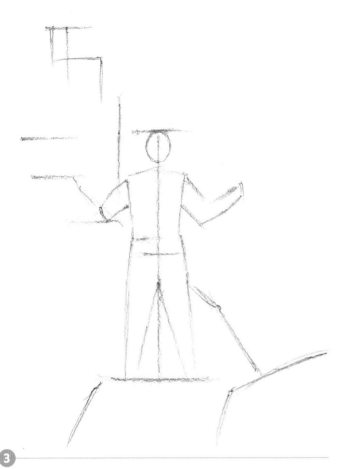

**3**

### Sketch the Castle and Rocks
Begin to develop the form of the castle. Sketch the basic shapes of the rocks, and sketch a line for the rocky hillside.

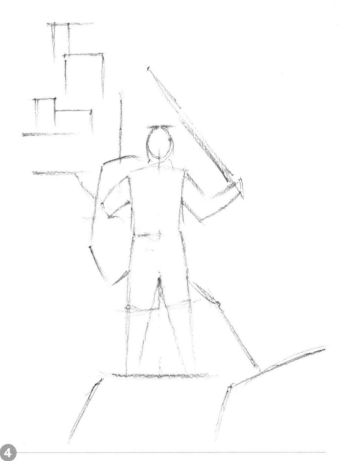

**4**

### Form the Castle and Knight
Continue drawing the basic shapes of the castle and the rocks. Add the knight's tunic, shield, and sword. Throughout the process, erase unwanted lines.

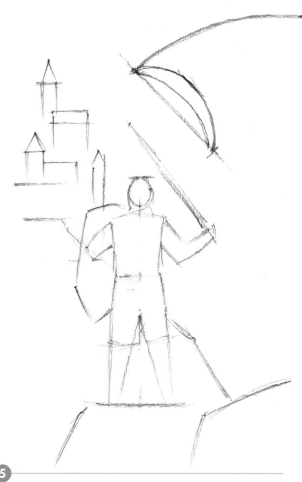

**5**

### Porportion the Dragon and Add to the Castle

Sketch a diagonal line. Add an arc going toward the upper-right corner. Add two smaller arcs to the diagonal line for the body. Add triangles to the castle for the rooftops.

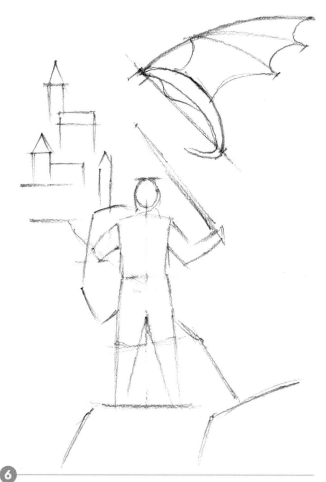

**6**

### Form the Dragon

Using a series of arcs, sketch the form of the dragon's wing. Add the torso, head, and tail to its body.

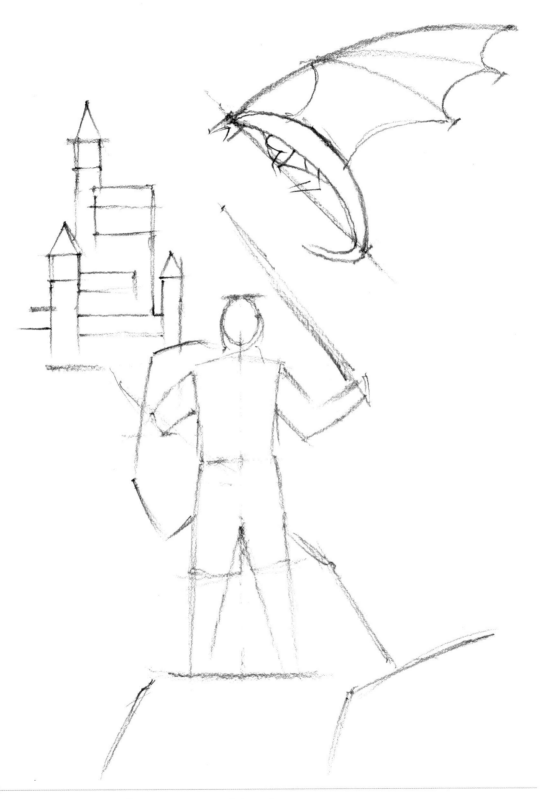

**7**

### Add Features to the Dragon and Castle

Add the mouth and legs to the dragon. Sketch lines for
the structure of the castle.

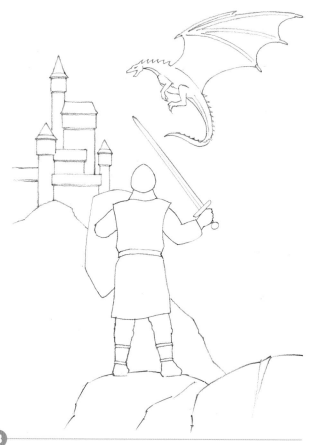

**8**

## Refine the Forms and Add Details

Refine the forms of the knight, castle, dragon, and rocks. Add details to the castle buildings. Add details to the dragon, including its claws and spikes.

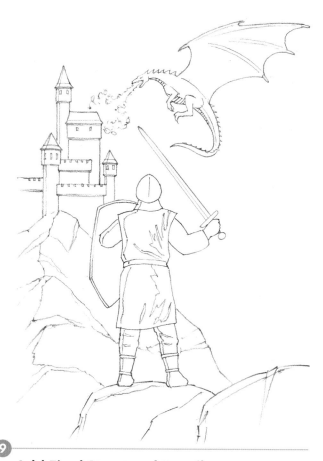

**9**

## Add Final Structural Details

Sketch lines for the shadows of the knight, castle, and rocks. Add windows and the square battlements to the top of the castle. Sketch the outline of the flames coming from the dragon.

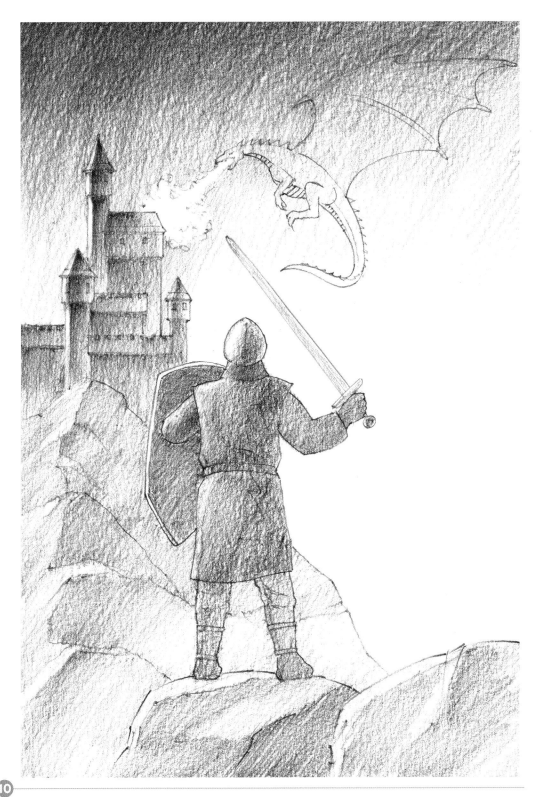

**10**

## Darken the Sky and Begin Adding Values

While keeping the flames white, begin darkening the top of the sky with long pencil strokes. Remembering that the light source is from the back upper left, begin adding light and middle values to the knight, castle, and rocks.

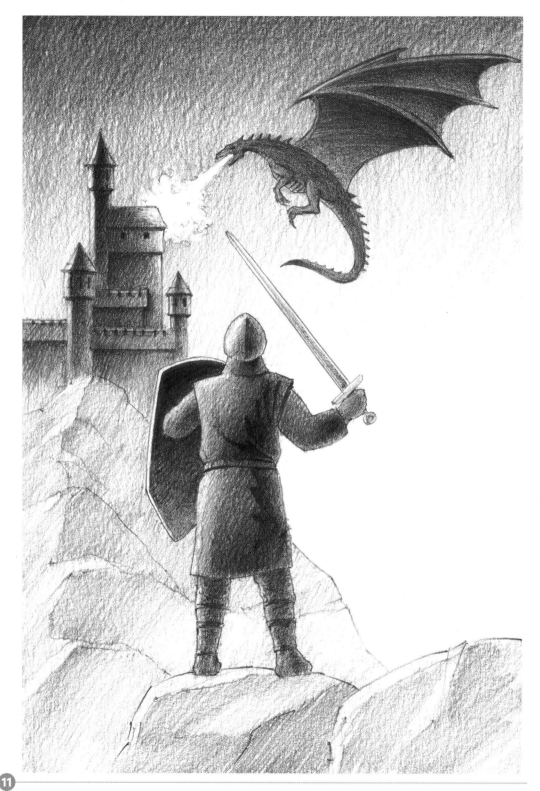

**⑪**

## Add Middle and Dark Values

Darken the top of the sky. Continue adding middle and dark
values to the knight, castle, and dragon.

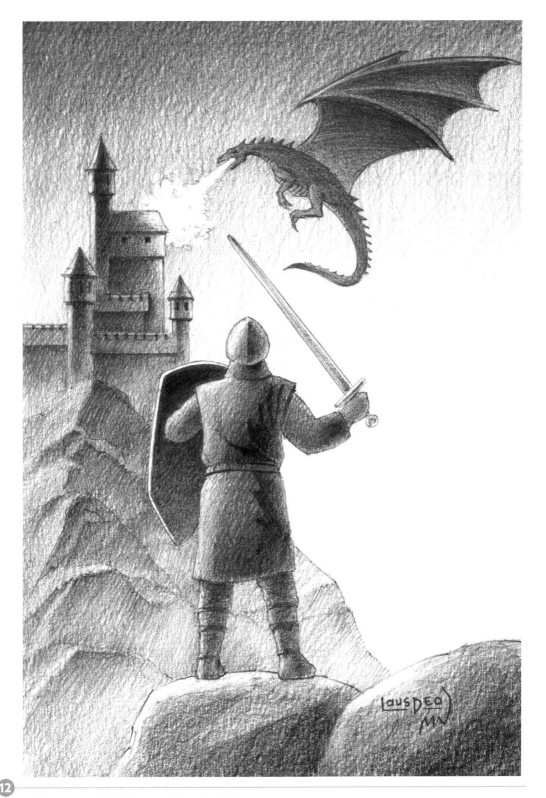

**12**

## Add More Middle and Dark Values

Add the middle and dark values to the rocks. Add more
detailed dark values to the knight and castle to complete
the drawing. Sign and date your drawing.

Storming the Castle
Graphite pencil on drawing paper
9" x 5" (23cm x 13cm)

# Farm Scene

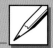    

Refer to the individual demonstrations for the Barn (page 82), Horse (page 56), Truck (page 94), and Tree Trunk (page 49) for more detailed instructions.

Placing the horizon near the middle of the barn gives the impression of looking across at the barn. This is different from the horizon line in the barn demo in chapter 2, which places the horizon line below the building. This gives the impression that the viewer is looking up at the barn.

**1**

### Sketch the Horizon and Corner of the Barn

Using the 2B graphite pencil, sketch a line about ⅓ from the bottom of the page as the horizon line. Add a vertical line going through the horizon for the forward-most corner of the barn.

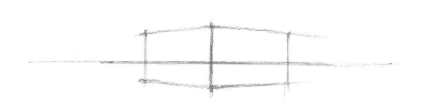

**2**

### Sketch the Sides of the Barn

From the vertical forward-most corner line, sketch two lines to the right that go toward the horizon. Then sketch two lines from the corner line to the left toward the horizon. Add vertical lines on the right and left that connect the horizontal lines to form the sides of the barn.

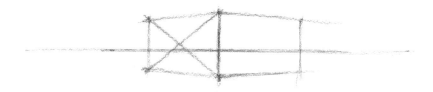

## Determine the Center of the Side of the Barn

Connect the opposite corners of the side of the barn to form an X, which determines the center of the side of the barn.

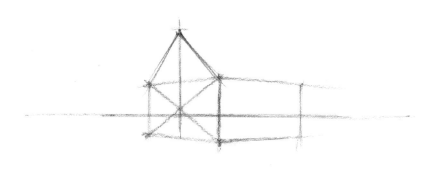

## Sketch the Roof Peak

Sketch a vertical line through the X to create the centerline. Sketch two diagonal lines down from the top of the centerline to the side corners to make the peak of the roof.

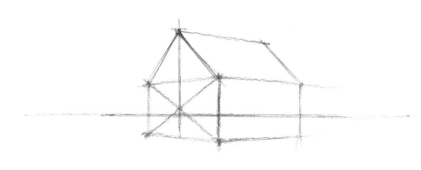

## Form the Roof

Sketch a sloped line from the roof peak to the right. Then sketch a diagonal line up from the far-right corner to form the roof.

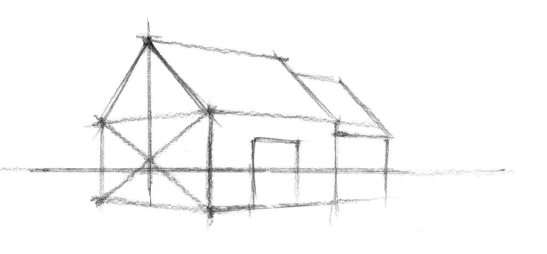

**6**

### Sketch the Addition and Door

Extend lines to the right of the side and the roof to
create the barn addition. Add the door.

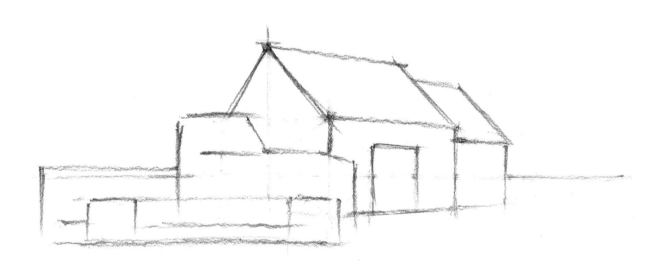

**7**

### Proportion the Truck

Proportion and sketch lines for the bottom, top, sides,
and tires of the truck. Erase any unwanted lines throughout
the process.

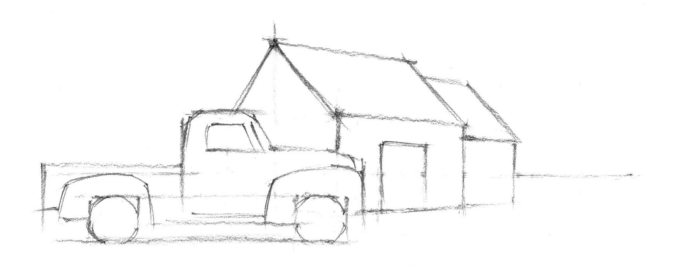

**8**

## Form the Truck
Round off the lines to form the tires, window,
and fenders.

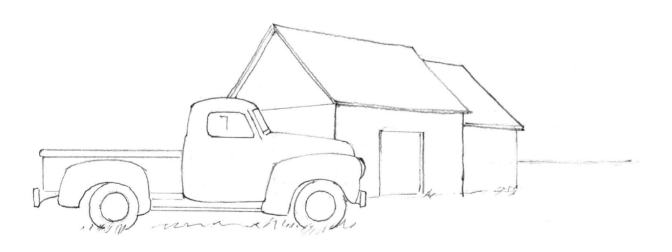

**9**

## Refine the Barn and Truck
Add features, such as the roof overhangs to the barn
and the wheel rims and running board to the truck.

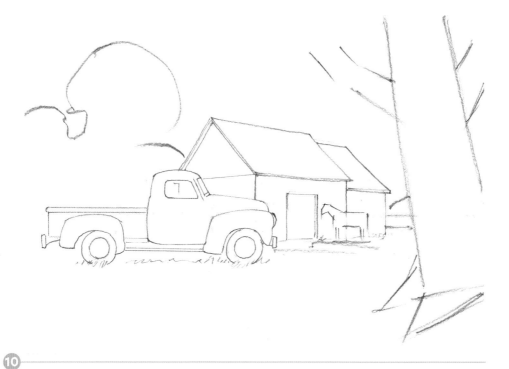

**10**

### Sketch the Horse and Trees

Look for the basic shapes, and sketch the forms of the
horse, foreground tree trunk, and background trees.

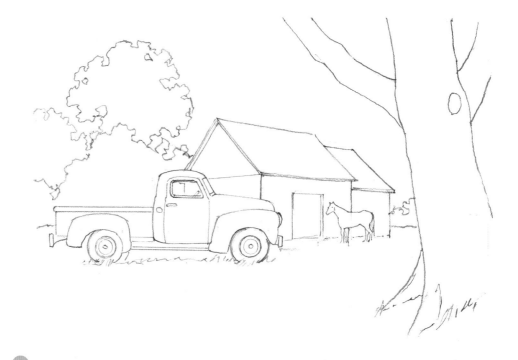

**11**

### Refine the Horse and Trees

Refine the lines, and develop the forms
and features of the horse and trees.

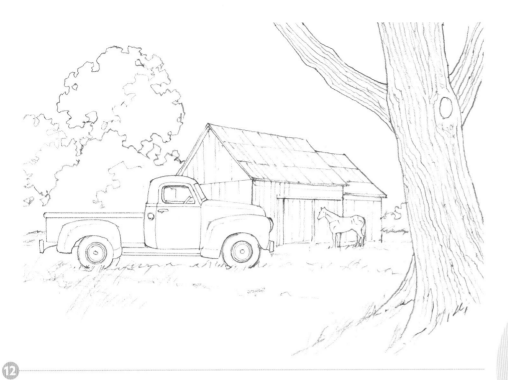

12

## Add Structural Details

Add lines for details, including the barn wood, tree bark, and grass. With the light source from the upper left, add shadow lines to the horse and background trees.

**ATTENTION TO DETAILS**

Pay attention to the visual details of each step in a demonstration. It's not about perfectionism; it's a step-by-step progression.

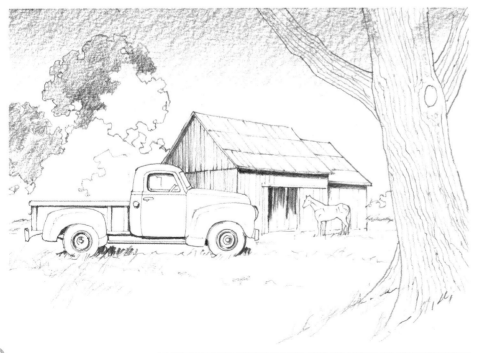

13

## Add the Fine Details and Add Values

Add details with the mechanical pencil. With a 2B graphite pencil, shade the sky using wide, flat strokes so that the sky appears darker at the top. Add middle values to the background trees, barn, and truck. Using an 8B pencil, darken the shadowed areas. By the completion of this step, all values in the value scale should be represented.

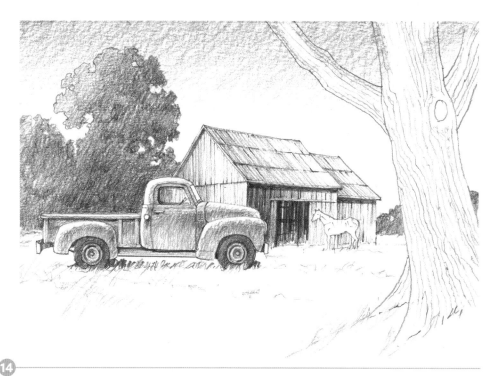

**14**

## Add More Values to the Barn, Truck, and Background Trees

Continue to form the elements using contrasting values to distinguish between the barn, truck, and trees.

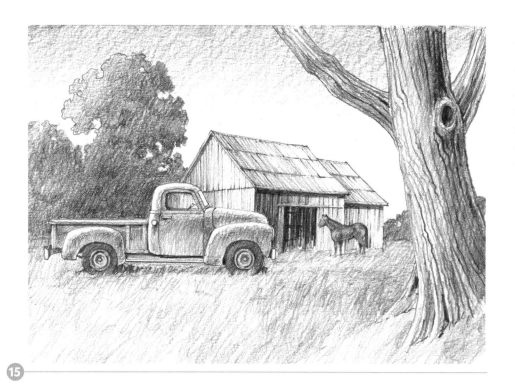

## Add Values to the Horse, Foreground Tree, and Grass

Add values to the overall scene so that most of the elements are filled with middle values.

**15**

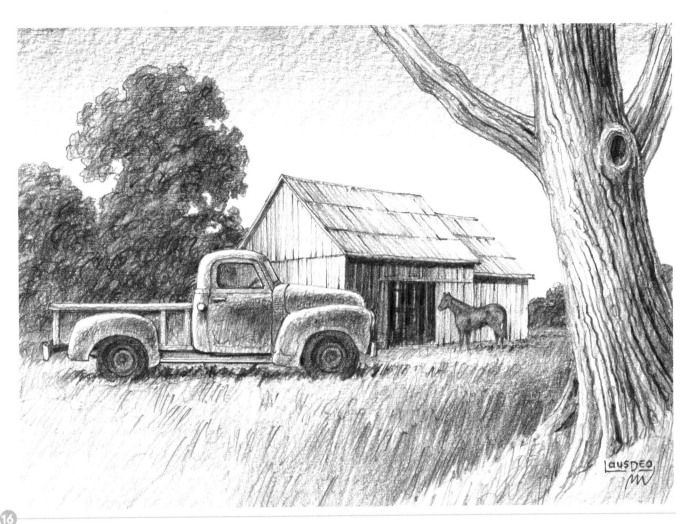

**16**

## Lighten and Darken Areas of the Drawing

Lighten areas of the tree bark by lifting graphite
with the kneaded eraser. Darken other areas, such
as the barn, truck, background trees, and grass.
Add detailed linework to the trees to complete the
drawing. Sign and date the drawing.

Stony Creek Farm
Graphite pencil on drawing paper
6" x 9" (15cm x 23cm)

137

# The Next Step

Apply the things you've learned by creating new compositions from demonstrations in this book. Then take it a step further. Create a greeting card, draw a portrait of a loved one or a favorite pet. Communicate with someone by drawing what you're trying to say. The possibilities are endless. Have fun and keep up the good work!

—Mark and Mary Willenbrink

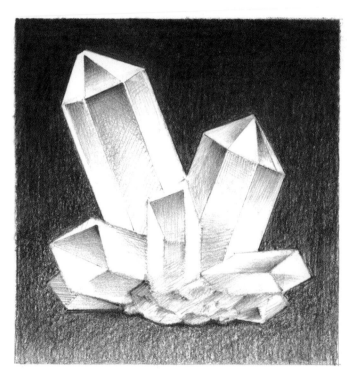

Quartz
Graphite pencil on drawing paper
4" x 4" (10cm x 10cm)

# Glossary

**Align:** to line up or arrange in a line

**Atmospheric perspective:** depth implied through values, colors and clarity; also referred to as "aerial perspective"

**Ballpoint pen:** a pen that utilizes a small metal ball at the writing tip

**Baseline:** a line at the bottom of a subject

**Centerline:** a line used to designate the center

**Centerpoint:** the point at the center of a square or rectangle

**Composition:** the arrangement of elements that make up a scene

**Contour drawing:** a sketch or drawing made from a single, uninterrupted line; also called "continuous line drawing"

**Contrast/contrasting values:** extreme differences between lights and darks or "values"

**Crop:** to trim the visible area of a scene or piece of artwork to better suit the drawing

**Cross-hatching:** two or more sets of parallel lines that cross each other to create texture in a drawing

**Direct observation:** to draw having the actual subject to view for observation

**Direction of light:** the direction of the primary light source of a subject or scene

**Drawing:** a completed piece of art using pencils or pen

**Drawing board:** a board made of Masonite or smooth wood used as a support for sketching and drawing

**Drawing paper:** heavier paper, 90lb or more, used for sketching or drawing

**Ellipse:** a circle drawn in perspective

**Eraser holder:** a device used to hold refillable vinyl eraser cartridges for controlled erasing

**French curve:** a tool used to create curves in a drawing

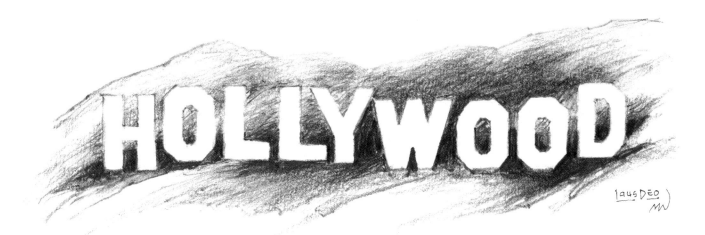

Hollywood Sign
Mechanical pencil on drawing paper
3" x 7" (7.6cm x 18cm)

**Gradated shading:** shading that varies, light to dark or dark to light

**Graphite pencil:** a pencil with the core—or lead—made of graphite

**Highlights:** an area where the light directed onto an object is most intense

**Horizon:** the line where the sky appears to meet the land or water

**Horizontal:** something that is goes from left to right or is level with the horizon

**Kneaded eraser:** a soft eraser used to lift lighter graphite pencil lines from paper by pressing down on its surface

**Lead:** also referred to as the core of a pencil, most commonly made with graphite

**Linear perspective:** depth implied through line, size, and placement of elements in a drawing or composition

**Masking tape:** tape used to attach sketching and drawing paper to a drawing board

**Measure:** to use a set distance as a gauge for comparison when sketching

**Mechanical pencil:** a pencil that uses refillable graphite for its lead

**Negative form:** the light form of a subject against a dark background

**One-point perspective:** linear perspective with only one vanishing point

**Paper content:** the materials that make up the paper

**Paper surface texture:** the degree of smoothness or coarseness of the paper surface; also referred to as the tooth

**Paper weight:** the measurement of the thickness or weight of individual sheets of paper

**Parallel lines:** lines that go in the same direction to a vanishing point

**Pencil extender:** a sleeve used to increase the length of pencils

**Pencil sharpener:** a handheld or stationary tool used for sharpening pencils

**Perspective:** the visual representation of depth

**Positive form:** the dark form of a subject against a light background

**Proportion:** to compare measurements when sketching

**Reference materials:** photos and drawings used to observe a subject or scene

**Ruler:** a long, straight tool used for measuring and for making straight lines

**Shade:** to darken or add values with line strokes

**Sketch:** a rough, unfinished drawing

**Sketch paper:** lightweight paper, 50 to 70lb, used for sketching

**Slip sheet:** a sheet of paper used to rest the hand over a drawing to prevent smearing of the graphite

**Structural sketch:** a sketch of the structure of a subject without adding values

**Symmetrical:** evenly balanced on both sides

**Two-point perspective:** linear perspective with two vanishing points

**Value scale:** a strip of cardboard or paper that displays a range of values from white to black

**Values:** the lights and darks of an image

**Vanishing point:** the point where parallel lines in linear perspective appear to meet

**Vertical:** straight up and down

**Vinyl eraser:** a plastic eraser used to remove darker pencil lines from the paper surface

# Index

## A

airplane, 92-93
aligning, 13, 112-115
angle aligning, 13
apple, 12-13, 38, 112-115
arch, 80, 81
atmospheric perspective, 18

## B

ballpoint pen, 7, 42
barn, 82-83, 130-137
baseball glove, 23
blind contour drawing, 114
boat, 98, 100-105
bread, 39

## C

cactus, 44, 116-121
candle, 33
candle with flame, 33
castle, 86-87, 122-129
castle scene, 122-129
centerline, 42, 66, 80, 81, 82, 84, 90
chest, 29
clothing 74-75, 122-129
composition scene icons, 21
continuous line drawing, 114
contour drawing, 114
contrast, 16, 24, 32, 43, 50

corn, 40
couch, 17, 28-29, 106-111
cove scene, 100-105
crop 66-67
curved lines, 90, 92

## D

depth, 14-15, 18, 27, 43, 62-63, 71, 89
desert scene, 116-121
direction of light, 16, 21, 33, 37, 38, 86
direction of light icons, 21
direct observation, 33, 38, 40, 41, 69, 70, 78, 111, 112-115
dog's nose, 14, 62-63
donut, 41
dragon, 64-65, 122-129
drawing boards, 8
drawing pad, 8
drawing, defined, 10-11
drawing tools, 7, 21
drawing tools icons, 21
drum, 22
duck, 50

## E

ear, 71, 72-73, 76-77
Eiffel Tower, 81
elephant, 52-53
ellipse, 22, 31, 35
eraser holder, 9

erasers, 9, 53, 54
extreme contrast, 16
eye, 68-69, 72-73

## F

face, 72-73, 76-77
   ears, 71, 72-73, 76-77
   eyes, 68-69, 73
   hair, 72-73, 76-77
   mouth, 69, 72-73, 76-77
   perspective in, 14
farm scene, 130-137

flames, 23, 24, 101-111
flower, 46
focal point, 104
forms, 17
French curve, 9, 81

## G

gift box, 25
grapes, 11-12, 43, 112-115
graphite pencils, 7, 21
gray scales, 17
guidelines, 85

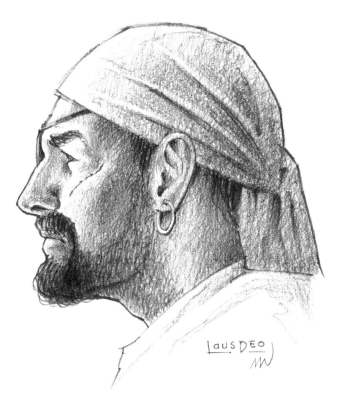

Pirate
Graphite pencil on drawing paper
6" x 6" (15cm x 15cm)

**H**

hair, 72–73
hand, 70, 78–79
highlights, 38
Hollywood sign, 85, 139
horizon, 14, 15, 82–83
horizontal aligning, 13
horizontal lines, 15, 45
horse, 56–57, 130–137
hot air balloon, 90–91, 116–121

**I**

ice-cream cone, 42
icons, about, 16, 21
iguana, 51
ink blobs, 42
interior scene, 106–111

**J**

jellyfish, 55

**K**

key, 32
kneaded eraser, 9, 53
knight, 74–75, 122–129
koala, 58–59

**L**

lettering, 85
lifting graphite, 53, 54
lighthouse, 84–85, 100–105
light source, 16, 21, 33, 37, 38, 86
linear perspective, 14–15, 18

line strokes, 19, 51
low contrast, 16

**M**

masking tape, 8
measuring, 12, 112–115
mechanical pencils, 7, 21
mine shaft, 89
moderate contrast, 16
mountains, 45, 116–121
mouth, 69, 72–73
mug, 12–13, 35, 112–115

**N**

negative forms, 17

**O**

octopus, 60–61
one-point perspective, 14–15, 28–29, 106–111
owl, 61

**P**

paper, 8
pencil grip 19, 52–53
pencil extenders, 9
pencils, 7, 21, 88
pencil sharpener, 9
pen, 7, 21, 88
perspective, 14–15, 18, 82–83
pipes, 27
pirate, 76–77
planter, 36
positive forms, 17
progress tracking, 22

proportioning, 13, 35, 45, 52, 63, 76, 112–115
pumpkin, 34

**Q**

quartz, 47

**R**

raven, 54
reference materials, 117
rocks, 48, 100–105
ruler, 9, 98

**S**

sea turtle, 66–67
shading, 19, 51, 52–53, 55
shadows, 37, 38
shapes, 12, 43, 86
shoes, 37
sketch, defined, 10
sketch pad, 8
slip sheet, 101
step-by-step progression, 135
still life composition, 112–115
straight edge, 30
structural sketch, 10, 12–15, 60, 62
supplies, 7–9, 21
symmetry, 42, 66, 80, 81, 84–85

**T**

texture, 19, 36, 49, 58–59, 61, 94
tree trunk, 49, 130–137

truck, 94, 130–137
two-point perspective, 15, 29, 82–83

**U**

ukulele, 30
unseen objects, 103

**V**

values, 10, 11, 16–19
value scale, 17, 27
van, 96–97
vanishing points, 14, 15, 28, 96–97, 111
vertical aligning, 13
vertical lines, 15, 42, 66, 80, 84, 90
vinyl eraser, 9
viper, 67

**W**

watch, 26

**X**

x-ray, 78–79

**Y**

yo-yo, 31

**Z**

zeppelin, 95

# Dedication & Acknowledgements

*Laus Deo*

*We dedicate this book to all our family and friends who have encouraged us to love life with childlike wonder.*

Thank you to our family and friends and to the many art students who encouraged us throughout this process. Thank you, Pam Wissman. This journey began with you as our acquisition editor. With a grateful heart, we thank our esteemed and talented Editor, Gleni Bartels, our creative and talented Art Director, Jennifer Markson, and our Creative Director, Irene Ledwith. Each of you are amazing—you captured our vision and helped us to create an art instruction book that offers a visual guide to drawing. A special thank-you to Carrie Kilmer, our CEO, for your continued support of our vision for this book. We also want to include our thanks to editors Pam Kingsley and Lauren O'Neal.

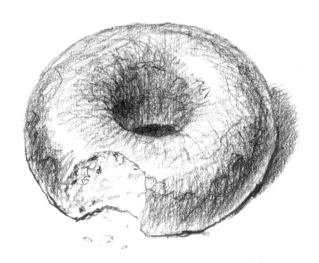

Donut
Graphite pencil on drawing paper
3" x 4" (7.6cm x 10cm)

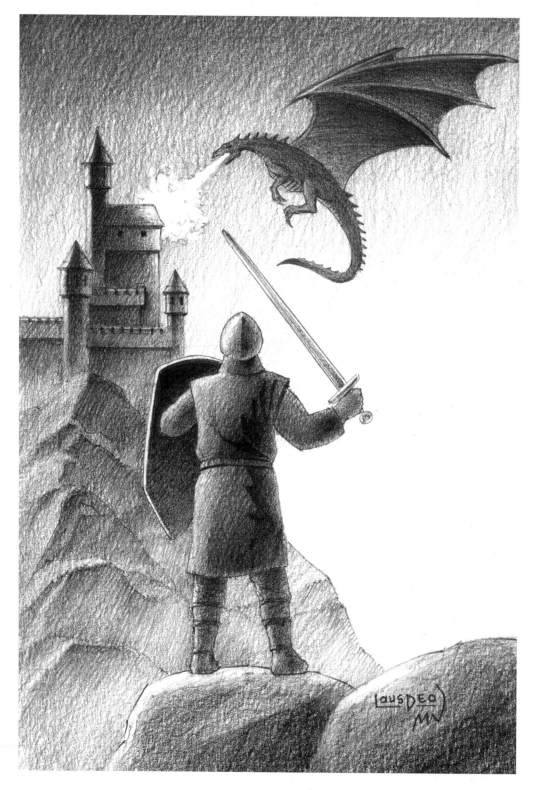

Storming the Castle
Graphite pencil on drawing paper
9" x 5" (23cm x 13cm)